National Museum of
the American Indian
(U.S.)

Treasures of the
National Museum of

SMITHSONIAN INSTITUTION

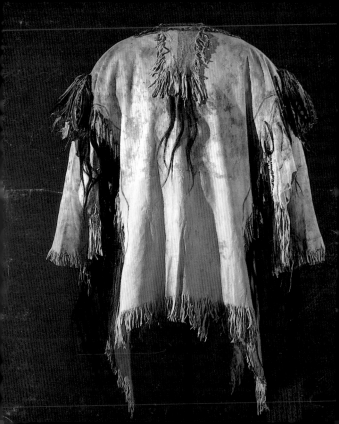

TREASURES OF THE
NATIONAL MUSEUM OF THE
AMERICAN INDIAN

SMITHSONIAN INSTITUTION

Foreword by W. Richard West, Jr.
Introduction by Charlotte Heth
Texts by Clara Sue Kidwell and Richard W. Hill, Sr.

A TINY FOLIO™

Abbeville Press Publishers
New York • London • Paris

Front cover: Minneconjou Lakota painted dance shield, from the 19th century, depicting a battle between Sioux and Absaroke (Crow) warriors. The man in the center is Hump, a Lakota chief. South Dakota. Diameter: 22⅜ in. (57 cm).

Back cover: Navajo Chief Blanket, late 19th century. New Mexico. Wool. 74⅜ x 53⅝ in. (186.5 x 136.5 cm).

Spine: Prairie Potawatomi doll, late 19th–early 20th century. Kansas. Hide, horsehair, cloth, silk ribbon, beads, animal claw, German-silver ornaments, wood, and vermilion. 10⅛ x 6 in. (25.8 x 15.2 cm).

Frontispiece: Shirt worn by Crazy Horse (Oglala Lakota), n.d. Painted hide, hair, and woodpecker feathers. 33 x 53 in. (84 x 134.5 cm).

Page 6: Chilkat Tlingit *shadakookh* (crest hat) of a bear, 19th century. Alaska. Carved and painted wood, abalone-shell inlay, copper, and twined spruce root. 14¼ x 12¼ in. (36 x 31 cm).

Page 10: Absaroke (Crow) moccasins, n.d. Montana. Hide with glass beads. 9½ x 4⅜ in. (24.2 x 11.2 cm).

Page 18: Kiowa cradle, c. 1910. Oklahoma. Beads on wood and cloth. Length: 41⅜ in. (104 cm).

Page 34: Kiowa headdress, n.d. Oklahoma. Cloth, eagle feathers, ermine, horsehair, and beads. Length: 76 in. (190 cm).

Page 98: Pima basket tray, n.d. Arizona. 2⅜ x 9¾ in. (6 x 24.8 cm).

Page 152: Tsimshian mask, early to mid-19th century. Carved and painted wood. Height: 9⅝ in. (24 cm).

Page 216: Sioux beaded deerhide, n.d. 45½ x 72 in. (115.5 x 183 cm).

Page 252: Curly, an Absaroke (Crow) scout for Lieutenant George Custer, n.d.

For copyright and Cataloging-in-Publication Data, see page 319.

CONTENTS

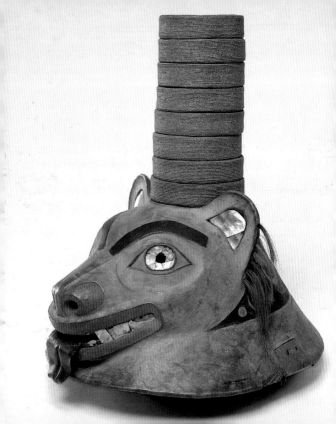

FOREWORD

The Smithsonian's National Museum of the American Indian (NMAI) is dedicated to the preservation, study, and exhibition of the life, languages, literature, history, and arts of Native Americans. Established by an act of Congress in 1989, the museum works in collaboration with the Native peoples of the Western Hemisphere to protect and foster their cultures by reaffirming traditions and beliefs, encouraging contemporary artistic expression, and providing a forum for Indian voices.

The museum will include three facilities, each designed following consultations between museum staff and Native peoples: the George Gustav Heye Center, an exhibition and educational facility that opened in New York in 1994; the Cultural Resources Center in Suitland, Maryland, scheduled to open in 1997, which will house the collections for conservation and study; and the museum on the National Mall in Washington, D.C., scheduled to open in 2001, which will serve as a center for ceremonies, performances, and educational programs, as well as an exhibition space for Indian art and material culture.

The collections of the former Museum of the American Indian, Heye Foundation, form the cornerstone of

the NMAI. Assembled largely by the wealthy New Yorker George Gustav Heye (1874–1957), the collections span more than ten thousand years of Native heritage, from ancient stone carvings to contemporary Indian paintings. Most of the more than one million objects in the collections represent cultures in the United States and Canada; many others are from cultures in Mexico and Central and South America.

As the only national institution in the United States whose mandate encompasses all the Native cultures of this hemisphere, the National Museum of the American Indian bears a unique responsibility to address important issues of cultural interpretation and representation. Most attempts to reexamine old conceptions and come to new understandings of Native cultures and peoples have begun and ended, unfortunately, with the objects themselves, without addressing the complex thinking that produced them. Conventional art history emphasizes aesthetics rather than cultural context, whereas disciplines such as anthropology, which do approach Native material in context, have sometimes minimized its beauty.

From a Native perspective, objects of material culture such as those shown in this book are inseparable from a cultural context that is very different from Western European tradition. For most Native peoples, the process of creating objects has always been as important as—and perhaps more important than—the objects themselves.

Whatever their aesthetic qualities, these objects are perhaps most powerful for what they tell us about the thinking of the people who made them. This book seeks to offer a new perspective on Native life and culture by illustrating how Indians from throughout the Americas have created aesthetically remarkable material inspired by their own experiences, cultural contexts, and world views.

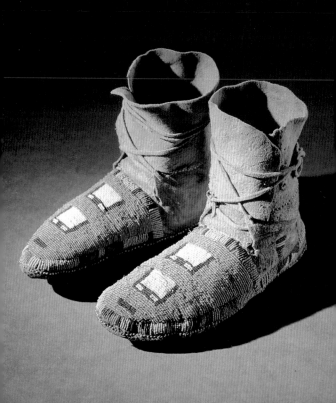

INTRODUCTION

Native artists of the Americas honor, preserve, exalt, and commemorate their universe through the works they create. On two continents and the Hawaiian Islands, over thousands of years, these artists have developed forms of expression for indoor and outdoor spaces, warm and cold climates, hard and soft surfaces, loud and quiet ceremonies, public and private events. Their arts are visible and invisible—the beaded clothing, glazed ceramics, and carved wood, stone, and ivory illustrated in this book, and the music and dances we envision as we look at the musical instruments and ceremonial dress shown here.

Material creations, such as those in the collections of the National Museum of the American Indian and other public and private collections, offer a particular, limited window on Indian cultures. Even photographs often present idealized images of Native subjects. The fact that few objects made of perishable materials survive means that archaeological evidence of Native peoples is incomplete. However, many things made of pottery, stone, and metal have been found, some of them decorated with images of everyday and ceremonial life. More is known about the meaning and use of Native household and ritual objects

after European contact—from explorers' diaries and drawings, from the work of anthropologists and collectors, and, most important, from the words of Indian elders who keep and pass on their peoples' histories.

The objects illustrated in this book reveal the wealth of the natural world that surrounded their makers and reflect the special relationship many Indians feel with certain plants and animals. A Chilkat Tlingit tunic (page 168) incorporates a Bear design that reflects a family history. A basket decorated with a rattlesnake design (page 102) commemorates the importance of that animal to the Cahuilla. A Kwakiutl button blanket (page 173) reflects the sacred importance of the cedar tree for Northwest Coast people. Even some of the materials used to make objects hold their own cultural significance, such as the sedge root, bulrush root, redbud, and willow in Pomo baskets, the various clays used to form Southwest pottery, and the wool in Navajo weavings.

Some objects trace the impact of trade on Native life and creativity—the exchange of goods and ideas among indigenous cultures before the Europeans came to this hemisphere and, later, between Natives and non-Natives. Tuscarora and Mohawk hats (page 45), Ojibwe bandolier bags (pages 88–91), Crow moccasins (page 10), and many other objects were beautifully decorated with European trade beads. A Teton Lakota parasol (page 145) and Huron pincushion (page 140) are whimsical examples of the use

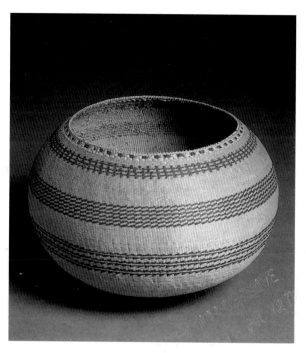

MARY BENSON (Pomo, 1876–1930).
Three-strand twined basket, n.d. California. Redbud
and willow. Diameter: 7 in. (17.8 cm).

13

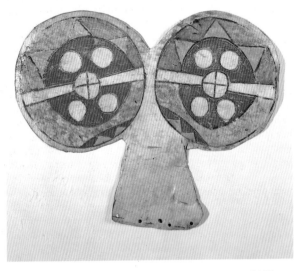

Absaroke (Crow) horsegear, n.d. Montana. Painted hide.
24⅞ x 30 in. (63.2 x 76.2 cm).

of traditional materials, such as quills and moosehair, to create objects influenced by European styles. Northwest Coast button blankets (page 173), Kuna *molas* (page 65), and Seminole clothing (pages 24, 59) use nontraditional materials such as mother-of-pearl buttons and trade cloth in designs that are grounded in centuries-old family, clan, and tribal histories and traditions. These and other objects influenced by contact and trade bear witness to the resilience of Native cultures in the face of change and to the vitality of Indian communities today.

Many objects illustrated here reflect the important role that music and dance have played for centuries in the social and spiritual lives of Indians. These arts sustain traditions and a sense of place within a cultural continuum that is still very evident. Native musicians, both past and present, have accompanied songs and dances on rattles, drums, rasps, flutes, whistles, and strings. Rattles made of deer hoofs, turtle shells, and cocoons were used by Native peoples throughout North America, as were rattles made of shells along the coasts and wooden rattles in forested regions (page 179). Today, dancers sometimes wear leg rattles made of tin cans and metal saltshakers, rather than turtle shells or hollow gourds (page 177). Carvers in Mexico and Guatemala made large wooden drums (page 176) whose echoes can still be heard in Central American music. Ceramic, wooden, and cane whistles and flutes have been played throughout the

Americas for centuries. Some are shaped into animal or human figures (page 182); some contain water to imitate the sounds of birds. Musical bows found in both North and South America argue for the existence of stringed instruments before European contact, as does the skill and enthusiasm with which many Native cultures adopted and adapted European guitars and fiddles. Apaches, for example, make fiddles from agave stalks (page 181).

Much of the material in the museum's collections reflects the maker's personal vision, representing emotions or beliefs within a cultural or religious context. Plains Indians often used powerful imagery on shields (pages 230–35) to protect warriors from enemy arrows and lances; Oto warriors used effigy clubs (page 229) representing animals who would give them strength in battle. In many Indian cultures headdresses were sometimes designed using animal horns that imparted the animals' characteristics—speed, strength, or courage—to the wearer. Feather headdresses illustrate the beliefs of Native cultures in the spiritual and protective power of birds—particularly eagles. Pictorial arts depicting ceremonies such as the Sun Dance and Snake Dance, war and hunting exploits, and community events not only illustrate the artists' personal creativity and vision but also honor the past and reinforce cultural identity and values.

I hope that, through their wonderful craftsmanship and great beauty, and through the power of the personal

visions many of them represent, the treasures illustrated here tell something about their makers' reverence for the world. I cannot express this better than the Ponca-Osage dancer and storyteller Abe Conklin, who said, "Every object that we made—from the smallest doll and the dice and dice bowls, to the leggings, shirts, and head-dresses—was made with prayer."

It is hard to imagine life as it might have been hundreds or thousands of years ago, when people saw the night sky without the interference of city lights or smog, when thousands of species of birds filled the world with their music. I hope that the images in this book will help you picture the wonder of that world and stimulate your curiosity about the people who lived there and the traditions they handed down to their descendants in Native communities throughout the Americas.

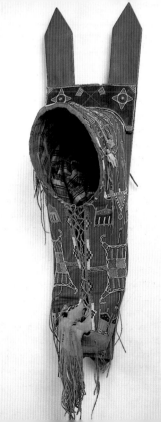

GROWING UP INDIAN

Children are very much a part of everyday life in Indian communities. At tribal council meetings, ceremonies, and social gatherings, young children are almost always present, observing their parents and learning the ways of adult life. Cradleboards (opposite and pages 27–29)—hooked over the pommels of saddles or perched on travois while the tribe traveled; or hung from the branches of trees while mothers tended the fields, gathered wild plants, or tanned hides—are emblematic of the fact that children went everywhere with their mothers.

Traditionally, children's toys were miniatures of adult implements, designed to teach important skills to girls and boys. On the Great Plains, girls learned to set up camp with miniature tipis, practicing the art of erecting the central framework of poles and hide covering, and positioning the smoke flaps at the top just right. A tiny bow and arrow might be fastened to a baby boy's cradleboard as a symbol of his future prowess as a hunter, and a young boy was often given a small bow and arrows with which to practice his skills. Ultimately, when he killed his first game, his family would honor him with a feast.

Dolls, too, can be more than playthings. Many Hopi parents in the Southwest still use katsina dolls to teach children about the different spiritual beings who are part of the Hopi world. Richard W. Hill, Sr., a member of the Tuscarora tribe in upstate New York, tells how Iroquois children were given cornhusk dolls with blank faces (page 32), in contrast to the sometimes elaborately lifelike dolls enjoyed by children now. The cornhusk dolls' blank faces allowed children to see the faces that the Corn Spirit wanted them to see.

Children in many contemporary Indian communities grow up surrounded by the sights and sounds of creative activity. They hear the rhythmic roll of a curved stone mano across the dried corn in a metate or the gentle patting noise of a Navajo weaver's comb tamping down the weft of her rug on the loom. Rina Swentzell, a member of Santa Clara Pueblo, describes her family: "My mother, my aunt, my sisters, everybody's sitting around the table making a pot. Children come in, grab a piece of clay and start to play with it. Meantime, everyone is talking and laughing and saying 'why'd you do that?' and the adults are playing with the clay as much as the kids are."

Extended family relationships are often the norm on reservations, where grandparents, parents, and children live close to each other. Children are constantly learning

from relatives, often across several generations. They hear the stories told by their parents and grandparents about how things were when they were young. They see the work of artists all around them. They see women doing beadwork and quilting, and men making wood or bone carvings. Perhaps they will learn to practice the same skills and pass them on to their children.

There is a term that is common in Indian community life today—"the seventh generation." Vine Deloria, Jr., a Lakota scholar and activist, explains that the term refers to the concept of Indians looking back at memories of their parents, grandparents, and great-grandparents, and ahead to knowing their children, grandchildren, and great-grandchildren. Each individual, then, stands at the center of seven generations. These generations represent both the past and the future, but most of all they embody the continuity of tribal culture. The metaphor of the seventh generation exemplifies what it means to grow up Indian.

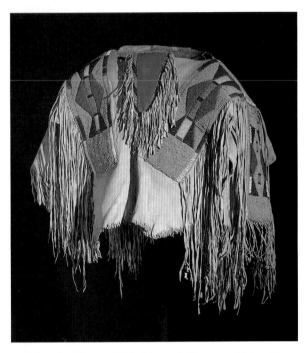

Absaroke (Crow) child's shirt, n.d. Montana. Hide with
beads and wool. Length: 16¾ in. (42 cm).

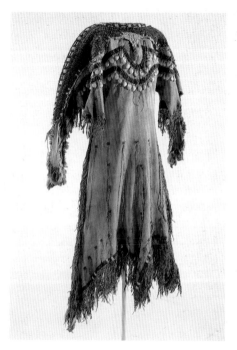

Northern Plains girl's dress, c. 1850. Deerhide, elk teeth, and beads. 65⅛ x 42⅛ in. (163 x 107 cm).

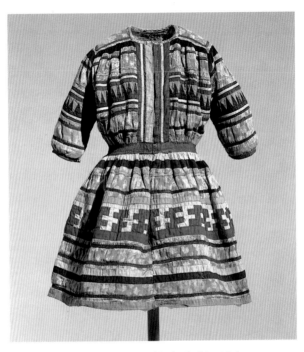

Miccosukee–Seminole boy's *foksikco.bi* (big shirt), 1925–35.
Florida. Calico cloth. 14¼ x 14¼ in. (36 x 36 cm).

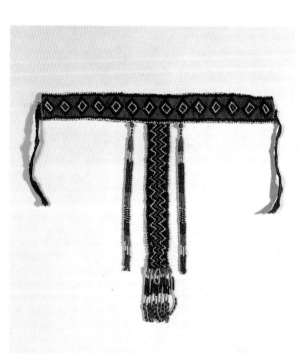

Apache necklace, early 20th century. Arizona.
Beads on cloth. 10¾ x 11⅜ in. (27 x 29 cm).

Lakota turtle amulets, late 19th–early 20th century.
9 x 7⅝ x 1⅛ in. (22.5 x 19 x 2.8 cm).

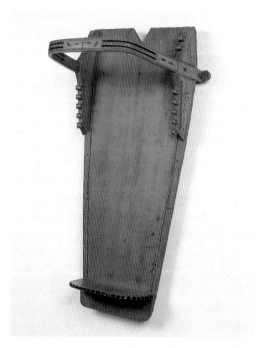

Seneca cradleboard, n.d. Wood. 28½ x 15½ x 10¾ in.
(72.4 x 39.4 x 27.3 cm).

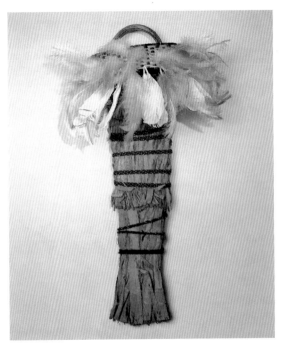

Yuma cradle, late 19th–early 20th century. Arizona.
Willow wood with woven-splint hood intertwined with wool
and decorated with feathers. 22¾ x 12¼ in. (58 x 31 cm).

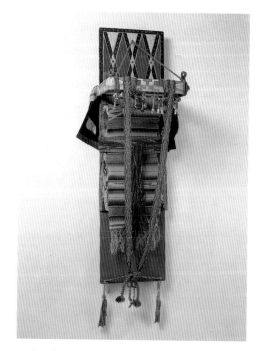

Wah-zah-zhe (Osage) *w'on-dop-she* (cradleboard),
early 20th century. Oklahoma. Wood and cloth decorated
with bells. 42½ x 13¾ x 13⅜ in. (108 x 35 x 34 cm).

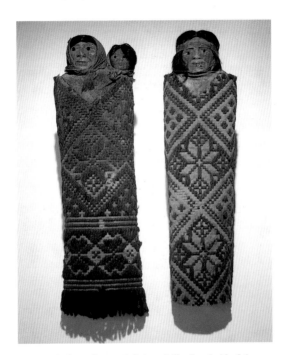

Huichol mother and father dolls, first half of the 20th century. Cornhusk wrapped with cloth. Jalisco or Nayarit, Mexico. Mother: 14⅛ x 3⅞ x 2½ in. (35.8 x 9.7 x 6.3 cm); father: 14¾ x 4¼ x 2⅜ in. (37.5 x 10.7 x 6 cm).

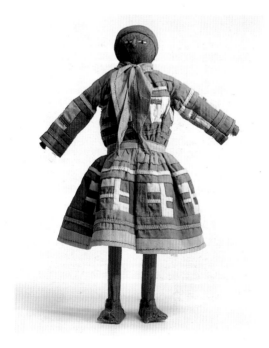

Miccosukee–Seminole doll, c. 1935. Florida. Palmetto fiber, embroidery floss, cloth, and beads. 15 x 10⅞ in. (38.1 x 27.7 cm).

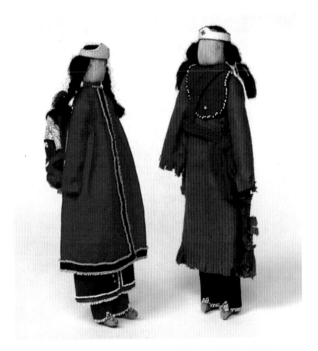

Tonawanda Seneca cornhusk dolls, n.d. New York.
Heights: 9½ and 10¼ in. (24 and 26 cm); widths: 4⅛ and
4¾ in. (10.5 and 12.3 cm).

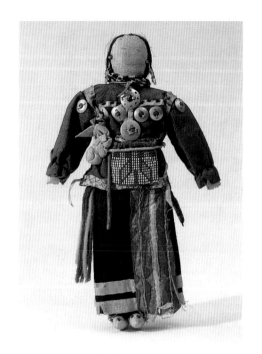

Prairie Potawatomi doll, late 19th–early 20th century.
Kansas. Hide, horsehair, cloth, silk ribbon, beads, animal
claw, German-silver ornaments, wood, and vermilion.
10⅛ x 6 in. (25.8 x 15.2 cm).

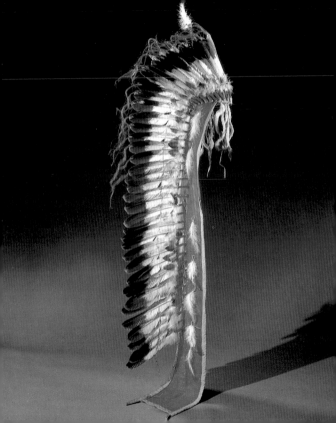

CLOTHING

The grand entry parade at Crow Fair in Montana is a thrilling spectacle. Tribal members, dressed in fine clothing, ride horseback past the announcer's stand. Many of the men wear feather headdresses. The women's deerskin and cloth dresses may be trimmed with elks' teeth or beautiful beadwork (page 62). Downy eagle feathers flutter from the ends of hair ties, and ermine skins wrap braided hair. The overall impact is that of a people who value their cultural traditions and relish the opportunity to display their pride through the fineness of their garments and the beauty of their horses.

During the powwow and rodeo that are part of the fair, held annually during the third week in August on the Crow Reservation, most Crow men and younger women wear jeans and cowboy shirts, unless they are taking part in competition dancing. Older women in print housedresses fan themselves as they sit watching the dances or rodeo from the sidelines. It is clear, however, that the Crow, even dressed in everyday clothing, are confident in their sense of identity.

Clothes do not make the man or woman. They do, nevertheless, give visual expression to value systems and

cultural norms. The elks' teeth that decorate garments (page 23) traditionally represent wealth and accomplishment. Since only an elk's two eyeteeth are used as decoration, their scarcity has made them particularly valuable. The teeth may now be purchased, but in the past a dress with a yoke completely covered with elks' teeth showed that a woman's father valued her highly and that her male relatives were skilled hunters who provided an abundance of elk meat for their families. For a married woman, an elk-tooth dress symbolized her husband's respect for her and his own high status as head of his family.

The collections of the National Museum of the American Indian include garments from many different cultures. We know a great deal about the people who made or wore some of these garments, such as Crazy Horse's shirt (page 2). In the case of others, we know about their history and significance. Ghost Dance shirts and dresses (page 170), for example, which represent personal experience and faith, were believed to protect their wearers from U.S. Army bullets. The paintings on these garments record the visions that came to people as they danced in an effort to bring back the buffalo and the spirits of their dead ancestors. But for much of the other clothing in the museum's collections, we can only surmise the meanings that are worked into the porcupine-quill decorations, beaded designs, or other kinds of expression.

In museums, clothing is often used to illustrate cul-

tural differences, but for Indian people who participate in cultural events, it evokes much more meaning. My mother once told me a rule about jingle dresses, worn by Anishinabe (Chippewa) women for powwow dancing. These dresses are festooned with rows of small, shiny metal cones that used to be, and occasionally still are, made from the lids of snuff tins. The skill of the dancer can be judged by the rhythm and tone of the sound the dress makes. The rule is that you don't mix jingles made from Copenhagen cans with those made from Skoal cans, because the tones of the two don't harmonize. This underscores the most important thing about a jingle dress—it is made to be heard as well as seen, and to be heard, it must move. The rhythmic clink and the metallic flash in the sun are as much a part of the dress as its material. Metal snuff cans came in with white traders and settlers, so it is obvious that jingle dresses postdate European contact for the Chippewa around Lake Superior. The jingle dress today, however, is very much the sign of a woman who knows and values her cultural roots and has learned the distinctive way of dancing that makes the dress she wears a thing of music and beauty.

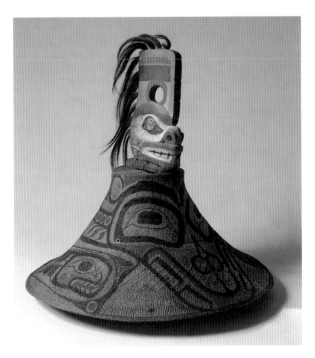

Haida hat, n.d. British Columbia, Canada. Woven and
painted spruce root with carved and painted wood.
17½ x 19½ in. (44.4 x 49.6 cm).

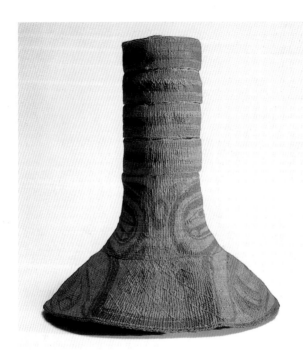

Haida hat, n.d. Northwest Coast. Woven and painted
spruce root. 13⅜ x 12⅛ in. (34 x 30.8 cm).

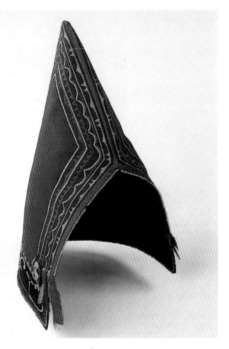

Micmac woman's cap, 19th century. Nova Scotia, Canada. Cloth, silk ribbon, and beads. 15½ x 9 in. (39.3 x 23.2 cm).

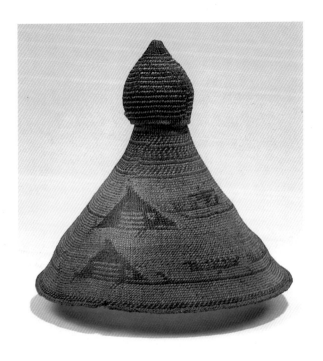

Nuu-chah-nulth (Nootka) basketry hat, 18th century.
British Columbia, Canada. 9⅞ x 8¼ in. (25 x 21 cm).

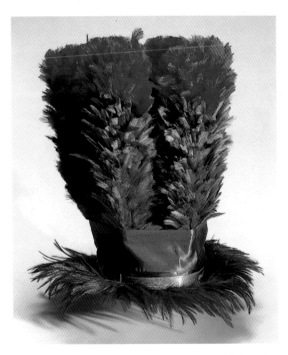

Osage wedding hat, n.d. Oklahoma. Broadcloth and
feathers. Height: 16¼ in. (40.7 cm).

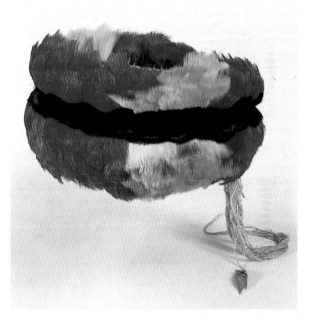

Shuar or Achuar *tawasap* or *etzengrutay* (feather headband),
early 20th century. Ecuador. Feathers. 20 x 5½ x 1⅜ in.
(51 x 14 x 3.5 cm).

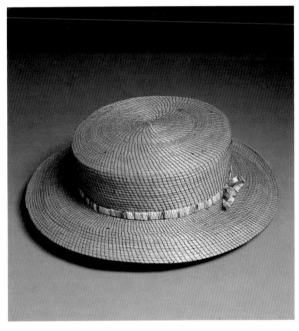

Ottawa woman's hat, n.d. Michigan. Woven sweetgrass
with quilled band. 3 x 12⅛ in. (7.5 x 30.7 cm).

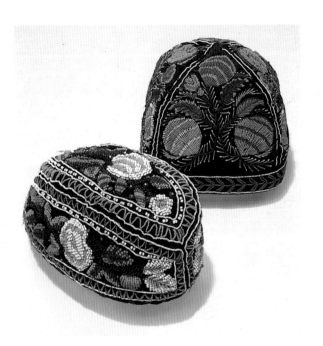

Tuscarora and Mohawk beaded hats, 19th century.
Canada. 5¾ x 7 in. (14.5 x 17.8 cm); 4 x 9¾ x 6 in.
(10.5 x 25 x 15.5 cm).

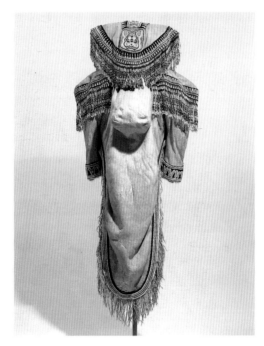

Aivilingmiut Iglulik *amautik* (woman's parka),
early 20th century. Near Chesterfield Inlet, Canada.
Caribou skin with fur lining, glass beads, and ivory
toggles. 48½ x 26 in. (123.5 x 66 cm).

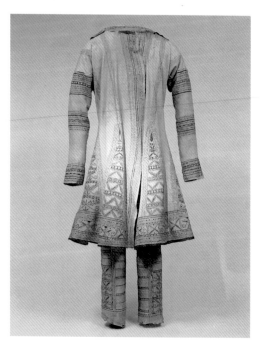

Innu (Naskapi–Montagnais) coat and leggings, early 1800s. Labrador, Canada. Painted caribou skin and sinew thread. Coat: 42¾ x 22¼ in. (109 x 57 cm); leggings: 18 x 4¾ in. (46 x 12 cm).

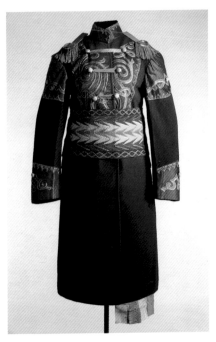

Osage woman's wedding outfit, n.d. Oklahoma. Cloth, broadcloth, ribbon, German silver, feathers, and beads. Coat, length: 48⅜ in. (120.1 cm); arrowhead sash, length: 101½ in. (253.6 cm).

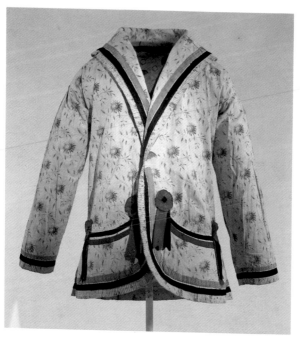

Shawnee coat, late 19th century. Oklahoma. Cloth.
Length: 33¾ in. (84.5 cm).

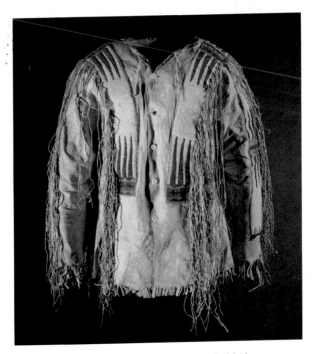

Ponca coat, n.d. Oklahoma. Beaded hide.
Length: 28⅜ in. (71 cm).

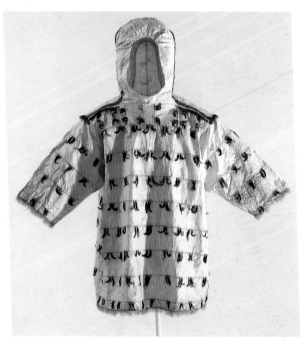

Siberian Yup'ik rain parka, late 19th–early 20th century.
Seal or walrus gutskin, sinew thread, and auk beaks.
45½ x 57½ in. (116 x 146 cm).

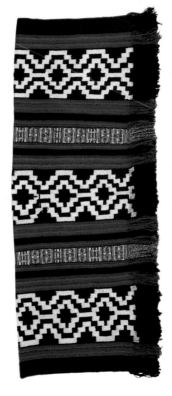

Mapuche *makuñ* (poncho), early 20th century. Chile. Wool. 26¾ x 64 in. (68 x 162.6 cm).

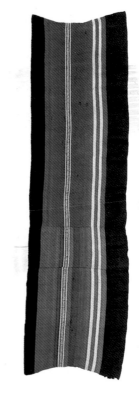

Quechua skirt, n.d. Peru. Alpaca wool.
30½ x 110 in. (77.3 x 279.5 cm).

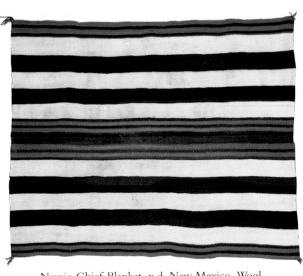

Navajo Chief Blanket, n.d. New Mexico. Wool.
54⅛ x 68¾ in. (137.5 x 174.8 cm).

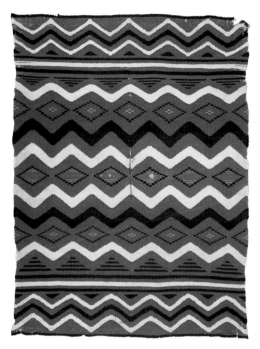

Navajo sarape poncho, 1825–60. New Mexico. Wool.
69½ x 52½ in. (176 x 133.4 cm).

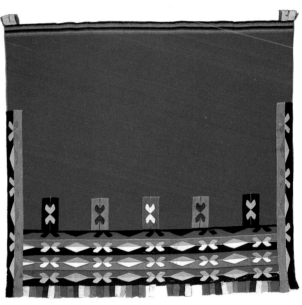

Wah-zah-zhe (Osage) *ha-a-hean* (ribbonwork blanket), n.d.
Oklahoma. 58⅛ x 63¾ in. (149 x 162 cm).

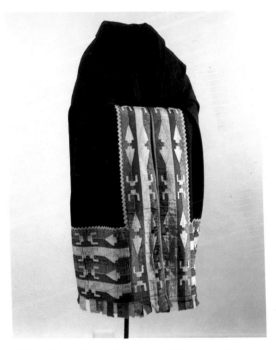

Wah-zah-zhe (Osage) *ha-a-hean* (ribbonwork blanket), 20th century. Oklahoma. 71¼ x 61 in. (181 x 155 cm).

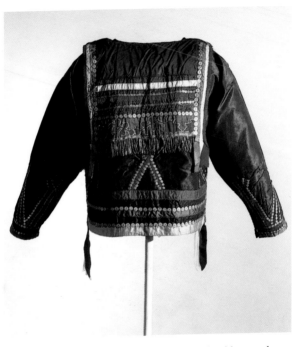

Ponca blouse, n.d. Oklahoma. Cloth with ribbonwork.
20⅜ x 19⅞ in. (50.9 x 49.6 cm).

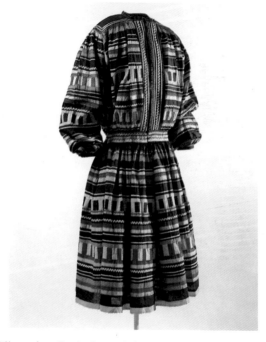

Miccosukee–Seminole man's *foksikco.bi* (big shirt), 1925–35.
Florida. Cotton. 69¾ x 52 in. (177 x 132 cm).

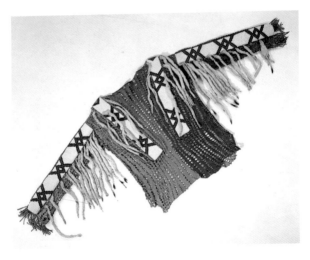

Blackfeet shirt, late 19th century. Montana.
Perforated deerhide, beads, weasel fur, and pigment.
28⅜ x 70¾ in. (72 x 180 cm).

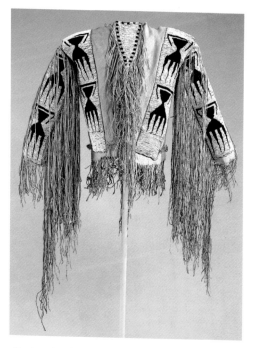

Jicarilla Apache shirt, c. 1880. New Mexico. Beaded hide.
42½ x 20 in. (108 x 51 cm).

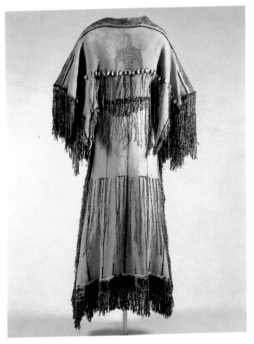

Southern Plains dress, late 19th–early 20th century. Hide.
55⅛ x 31½ in. (140 x 80 cm).

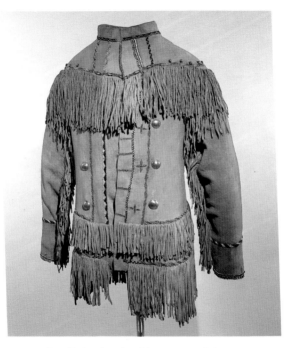

San Carlos Apache shirt, c. 1880. Arizona.
Beaded deerhide. Length: 43¼ in. (108 cm).

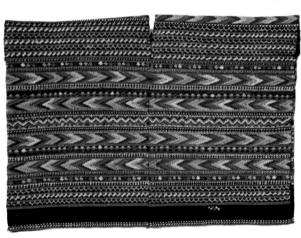

Kaqchikel Maya *huipil* (woman's blouse), early 20th century.
Guatemala. Handwoven cloth brocaded with silk thread.
24 x 34¼ in. (61 x 87 cm).

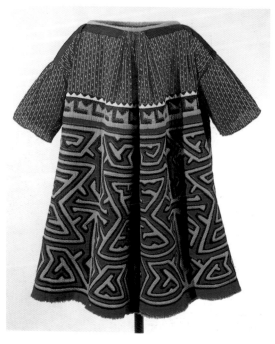

Kuna *mola* (woman's blouse), early 20th century.
Kuna Yala, Panama. 25⅛ x 23⅜ in. (64 x 59.5 cm).

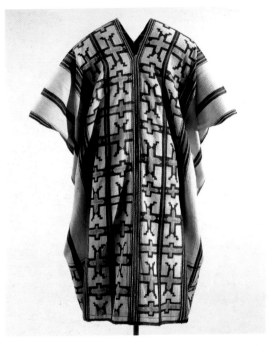

Piro *ikanopi* (man's shirt), early 20th century. Yarinacocha, Peru. Painted cloth. 47¼ x 31½ in. (120 x 80 cm).

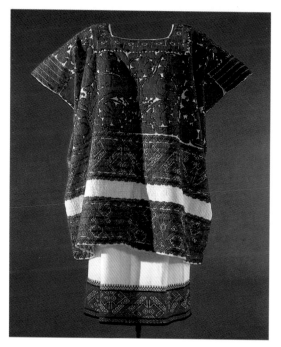

Mixtec *huipil* (woman's blouse) and *enredos* (skirt), n.d.
Mexico. Woven and embroidered cotton. Blouse: 38 x 35 in.
(96.5 x 88.9 cm); skirt: 28¾ x 26 in. (73 x 66.1 cm).

Piro *emkatceri* (woman's skirt), late 19th–early 20th century.
Urubamba River, Peru. Length: 26⅜ in. (66 cm).

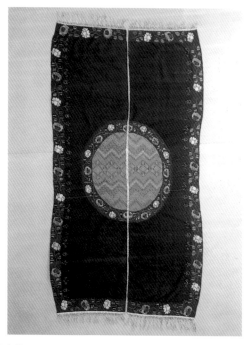

Saltillo sarape with crocheted strip, 1865–80. Northern
Mexico. Wool. 91½ x 46½ in. (232 x 118.5 cm).

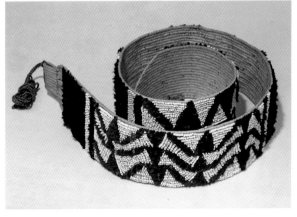

Konkow (Northwestern Maidu) *wa-to* (feather-and-
bead belt), n.d. California. Feathers and beads.
69¾ x 4½ in. (177.3 x 11.5 cm).

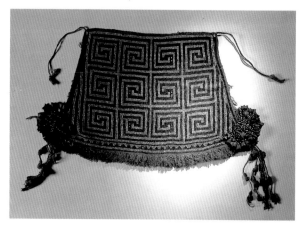

Yekuana *muaho* (beaded apron), early 20th century.
Upper Orinoco River, Venezuela. 9⅞ x 13¼ in.
(22.5 x 33.5 cm).

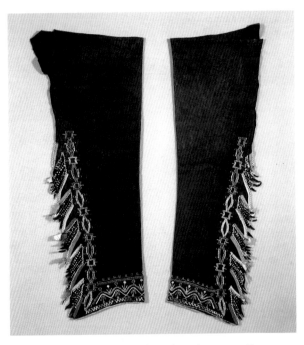

Iroquois leggings, late 18th–early 19th century. Eastern
Woodlands. Beaded deerhide. Height: 27½ in. (68.6 cm).

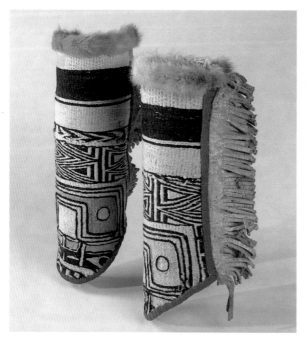

Dance leggings made from a *yeil koowu* (Raven's Tail-style) robe, early 19th century. Collected from the Nisga'a village of Gitlakdamiks, British Columbia, Canada. Mountain-goat wool. 12¼ x 11¾ in. (31 x 30 cm).

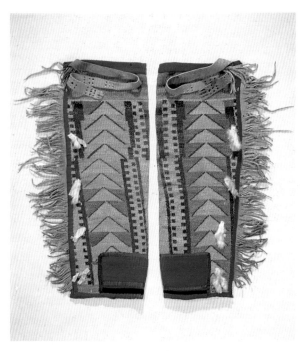

Walla Walla leggings, late 19th century. Washington.
Woven cornhusk. 26⅜ x 15¾ in. (67 x 40 cm).

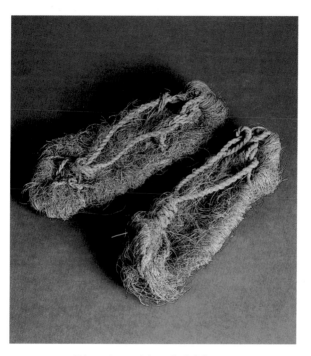

Diegueño sandals, n.d. California.
11⅛ x 4⅜ x 1½ in. (28.1 x 11.7 x 3.8 cm).

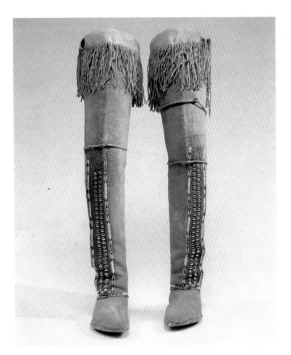

Southern Plains woman's boots, late 19th–
early 20th century. Height: 31¼ in. (78 cm).

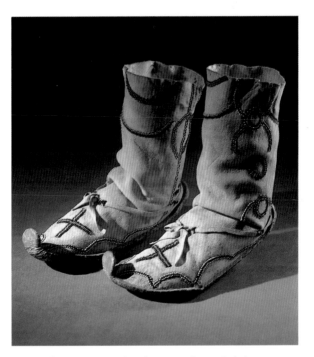

White Mountain Apache moccasins, n.d. Arizona.
Deerhide uppers, cowhide soles, glass beads, and sinew.
16¼ x 4½ in. (41.2 x 11.4 cm).

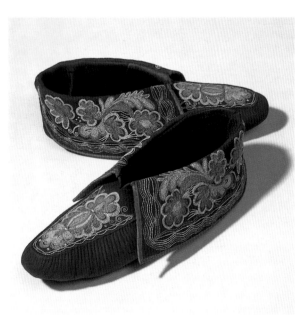

Huron moccasins, c. 1830. Quebec, Canada. Hide with
quillwork and moosehair. Length: 9⅛ in. (22.9 cm).

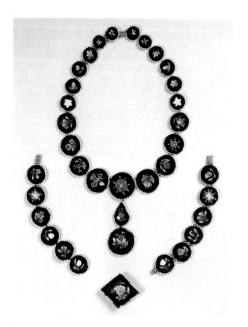

Huron ornaments (brooch, pair of bracelets, necklace with pendant), n.d. Eastern Woodlands. Cloth-covered disks with dyed moosehair embroidery. Brooch: 2¼ x 2 in. (5.5 x 5 cm); bracelets, lengths: 7⅝ and 7⅜ in. (19 and 18.5 cm); necklace, length (from clasp to pendant): 13¾ in. (34.5 cm), width of largest disk: 1¾ in. (4 cm).

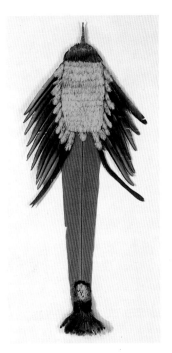

Kaapor *rembe-pipo* (man's labret), 20th century. Maranhão,
Brazil. Scarlet macaw and cotinga feathers. 11⅞ x 4⅞ in.
(30.2 x 12.3 cm).

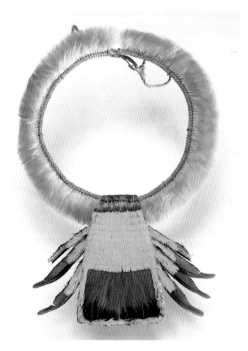

Kaapor *tukaniwar* (woman's feathered necklace),
20th century. Maranhão, Brazil. Toucan and cotinga
feathers. 9 x 6¼ in. (23 x 16 cm).

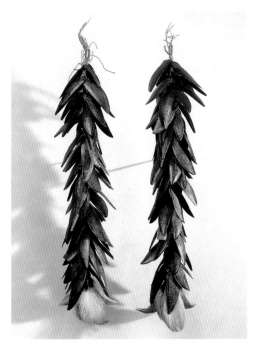

Shuar or Achuar *akitiai* (ear ornaments), n.d.
Ecuador. Beetlewing covers and toucan feathers.
11½ x 2½ in. (29 x 6.5 cm).

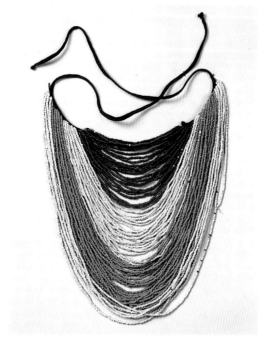

Shuar or Achuar *nunkutai* (woman's bead necklace), n.d.
Ecuador. 26½ x 8½ in. (67.5 x 21.5 cm).

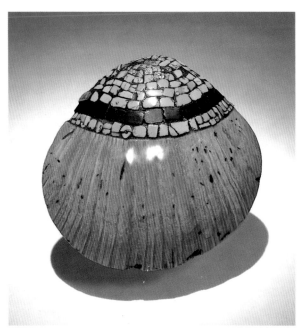

Shell pendant, 900–1250. Found at Pueblo Bonito,
Chaco Canyon, New Mexico. Shell inlaid with turquoise
and jet. 3 x 3¼ x 1 in. (7.7 x 8.1 x 2.5 cm).

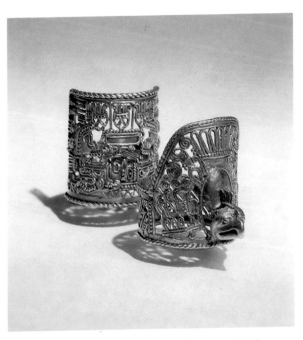

Mixtec rings, 1450–1521. Valley of Oaxaca, Mexico.
Gold filigree. Diameters: ¾ in. (1.8 cm); ⅞ in. (2.2 cm).

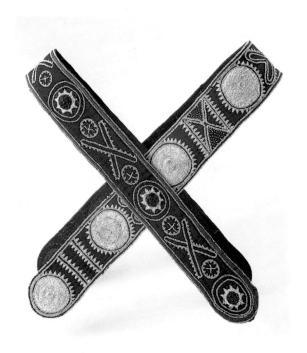

Choctaw *eskofatshi* (beaded bandoliers), c. 1907. Mississippi.
Wool with cloth appliqué. 46½ x 3¼ in. (118 x 8.1 cm);
49½ x 3½ in. (125.6 x 8.8 cm).

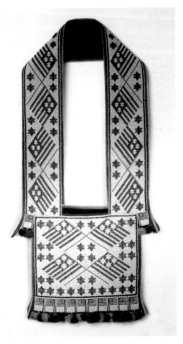

Winnebago bandolier bag, n.d. Great Lakes. Beaded cloth.
34 x 14½ in. (86.3 x 37.8 cm).

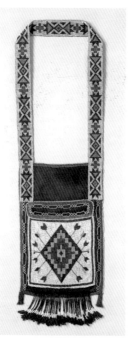

Ojibwe bandolier bag, n.d. Great Lakes. Beaded cloth.
26 x 7¾ in. (66.1 x 19.7 cm).

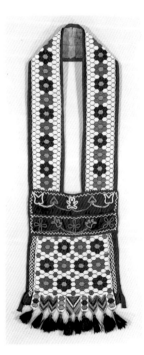

Ojibwe bandolier bag, n.d. Great Lakes. Beaded cloth.
42½ x 13¼ in. (108 x 33.6 cm).

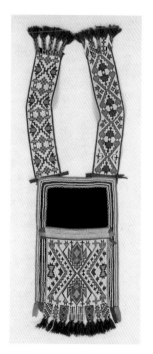

Ojibwe bandolier bag, n.d. Minnesota. Beaded cloth.
48 x 13¼ in. (122 x 33.7 cm).

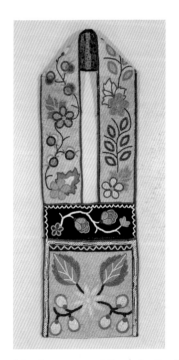

Ojibwe bandolier bag, c. 1890. Wisconsin. Beaded cloth.
38½ x 12½ in. (97.8 x 31.8 cm).

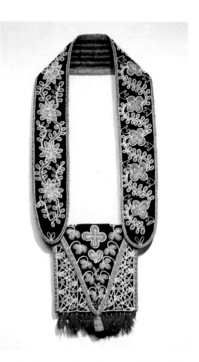

Bandolier bag, n.d. Southeastern United States.
Beaded cloth. 27¾ x 12¼ in. (70.5 x 31 cm).

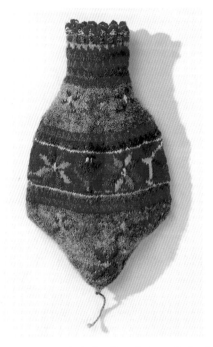

Aymara *ch'uspita* ("one little bag"), n.d. Peru. Knitted wool.
9½ x 5½ in. (24.1 x 14 cm).

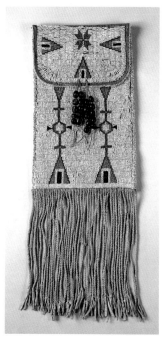

Kiowa bag, n.d. Oklahoma. Beaded hide, braided cording, and tin cones. 20½ x 7½ in. (52 x 19 cm).

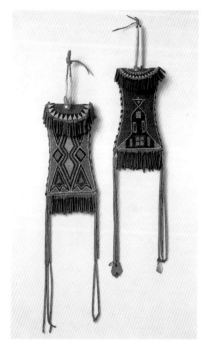

Kiowa beaded bags, early 20th century. Oklahoma.
Approximately 16¾ x 3½ in. (43 x 9 cm).

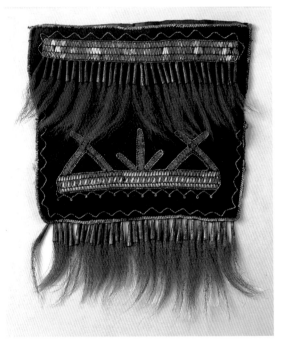

Lenape (Delaware) bag, n.d. Eastern Woodlands.
Deerhide with quills, tin cones, and feathers.
11⅛ x 8⅜ in. (28.5 x 21.3 cm).

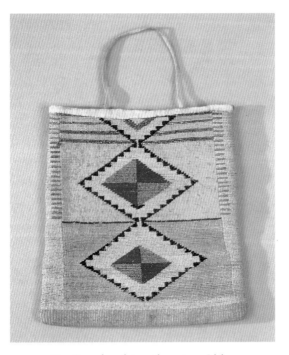

Nez Perce bag, late 19th century. Idaho.
Woven cornhusk. 10⅜ x 10⅜ in. (26 x 26 cm).

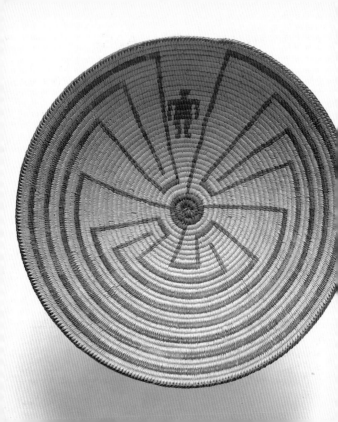

HOUSEHOLD AND
EVERYDAY OBJECTS

Many Native societies believe that the sun's path across the sky is a metaphor for our own lives. Each day that dawns begins another cycle of renewal. The sun rising in the east brings the new day forward. The setting sun ends daily activities as night begins, marked by the rising moon. No day is common—every day has spiritual meaning.

Objects made for everyday use, like those illustrated in this chapter, often held special sacredness for the people who made them. Though these things might be regarded by observers as utilitarian or secular, everyday objects were imbued by their makers with some of the same cultural and personal beliefs, world views, and values found in ceremonial and sacred objects.

Traditionally, mornings often began with a prayer or special song to greet the day, followed by washing or by drinking water—sacraments in themselves. Water jars (page 125), rawhide containers, and gourds had practical use, but they also held deeper meaning as containers of the life-giving power of water. Similarly, fire keepers used the simplest of tools to create something that was

sacred in itself—fire. Fire-making tools and materials thus derived a power of their own.

The preparation of food was also a meaningful ritual. Food has power—it is through food that we live. We still gather to feast daily, to enjoy the many bountiful gifts of creation. Baskets for sifting grain or washing corn (page 104), pottery jars for mixing or cooking (pages 109, 123), wooden trays for serving were all more than simple utensils—they became extensions of the gift of food.

Tools such as awls, knives, scrapers, hammers, axes, and even spoons (pages 146–48) often had family, clan, or other communal symbols incorporated into their designs. Some tools were elaborately decorated, as if the care put into constructing a tool made the tool itself more effective.

Today, we use everyday objects that are made by others and tend to regard household tools and kitchenware as mass-market products. We may purchase things that have brand names attached to them as a standard of quality, but there is no real feature that distinguishes them from the millions of other such objects used in homes everywhere. These objects would have much more significance, however, if we made them ourselves. They would reflect the skill required to make them and the creative ingenuity that inspired their design. There is a special satisfaction that comes from using tools, implements, cookware, containers, and other everyday items that are made by hand.

The creative process is a kind of ritual. Native artists take natural materials that are imbued with spiritual power and transform them into objects of beauty. Bark is the flesh of trees that is made into baskets or clothing. Leather is the skin of animals that is transformed into clothing. The living spirit of wood, shell, stone, clay, turquoise, antler, and other materials is harnessed into objects of identity and belief. While these objects might not be considered sacred in the sense that ritual objects are sacred, they too have a creative power that is clearly understood by people who make things with their hands and who value every day as sacred.

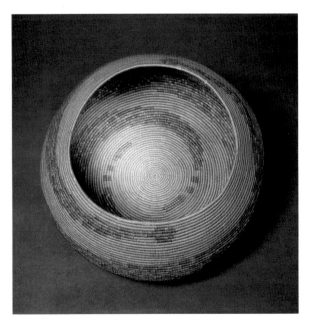

Cahuilla basket with rattlesnake design, n.d.
California. 6¾ x 14⅛ in. (17.3 x 35.8 cm).

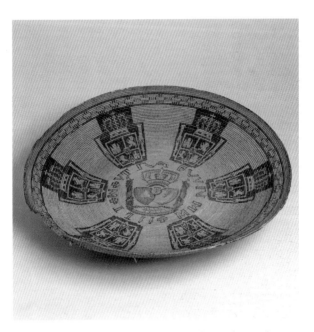

Chumash basket with Spanish coin design, late 18th–
early 19th century. California. Height: 3⅞ in. (10 cm);
diameter: 19⅞ in. (48 cm).

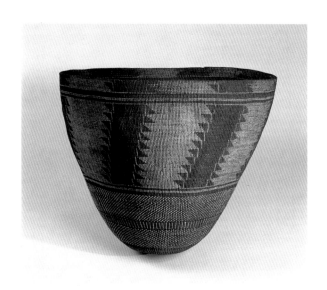

Hupa seed-gathering basket, late 19th–
early 20th century. California. Height: 18¾ in. (48 cm);
diameter: 23¼ in. (59 cm).

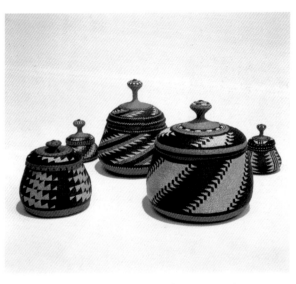

ELIZABETH HICKOX (Karuk, 1873–1947).
Lidded baskets, 1910–30. California. Heights: 2⅝ to 5¼ in.
(6.5 to 13.5 cm); widths: 2⅛ to 5½ in. (5.5 to 14 cm).

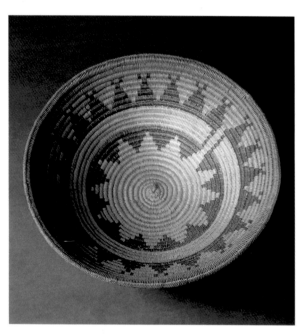

Navajo basket, possibly Ute- or Paiute-made, n.d.
New Mexico. 4⅞ x 16 in. (12.5 x 40.5 cm).

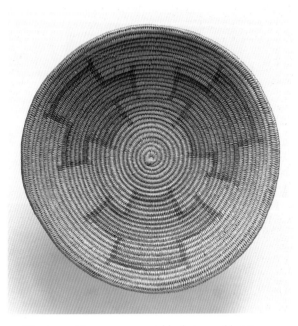

Navajo wedding or ceremonial basket, possibly Ute- or Paiute-made, n.d. Arizona. 3⅜ x 13⅞ in. (8.5 x 35.4 cm).

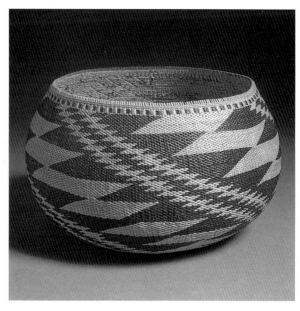

MARY BENSON (Pomo, 1876–1930).
Bamtush-weave basket, 1900–1930. California.
Redbud and willow. Diameter: 7 in. (17.8 cm).

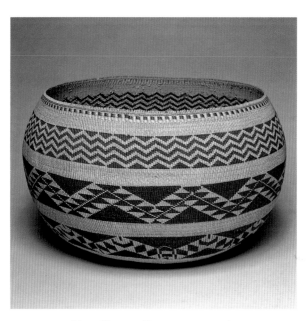

MARY BENSON (Pomo, 1876–1930).
Cooking basket, 1900–1930. California.
9½ x 14 in. (24 x 35.5 cm).

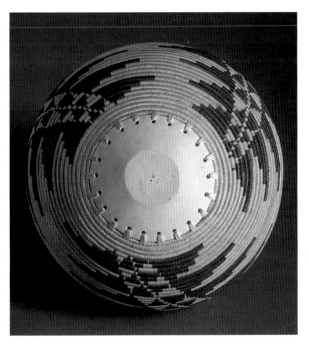

WILLIAM BENSON (Pomo, 1862–1930).
Three-stick coiled basket, 1900–1930. California. Sedge
root, bulrush root, and willow, with magnesite disk.
Diameter: 5 in. (12.7 cm).

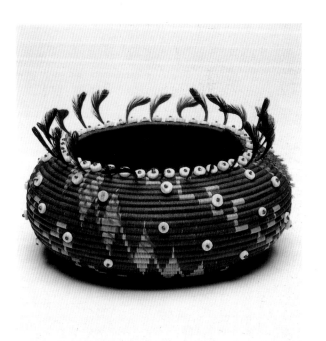

Pomo basket, n.d. California.
3⅜ x 6¾ in. (8.5 x 17 cm).

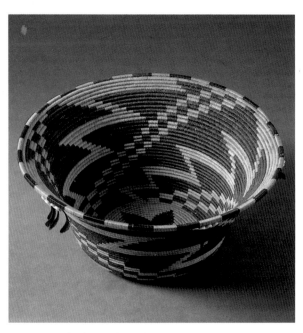

Pomo basket, n.d. California. Sedge root, bulrush root, and willow, with shell beads and feathers. Diameter: 11⅞ in. (30 cm).

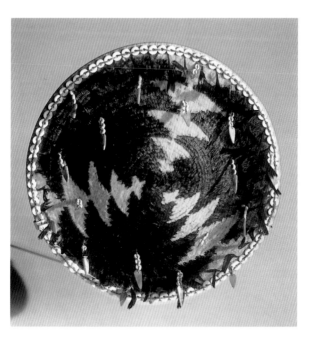

Pomo basket, n.d. California. Vegetal fibers with feathers
and shells. Diameter: 8 in. (20.2 cm).

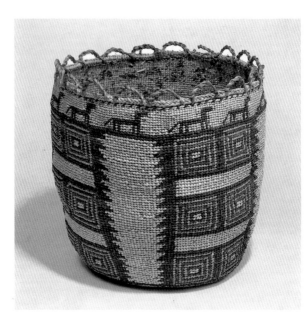

Basket with Skokomish design, 19th century. Collected
from the Quinault village of Taholah, Washington.
Height: 10⅛ in. (25.4 cm).

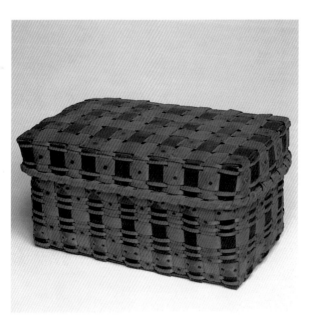

Tunxis or Mohegan wood-splint storage basket, c. 1840.
Connecticut. 9¾ x 7 x 5¼ in. (25 x 18 x 13.5 cm).

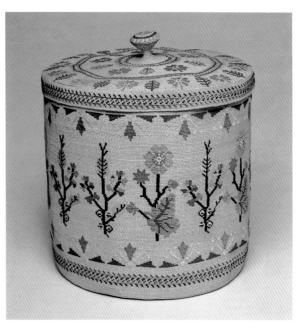

Unangan (Aleut) basket and cover, late 19th century. Alaska.
Grass with silk thread. 7½ x 7⅛ in. (19 x 18 cm).

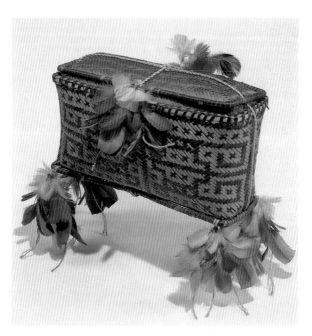

Waiwái *pakára* (basket), 20th century. Brazil. Vegetal fibers with feathers. 4¾ x 9 in. (12 x 24 cm).

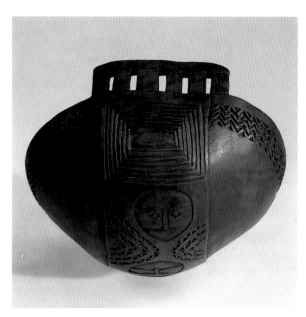

Chehalis bowl, 19th century. Columbia River, Washington.
Carved sheep horn. 4⅞ x 8 in. (12.4 x 23 cm).

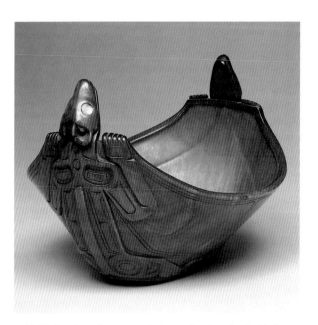

Haida bowl, 19th century. Prince of Wales Island, Alaska.
Carved sheep horn. 4⅝ x 7¼ in. (11.5 x 18 cm).

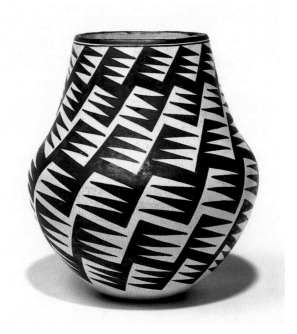

LUCY LEWIS (Acoma Pueblo, 1895–1992). Black-on-white pottery jar, c. 1969. New Mexico. 8 x 7 in. (20.5 x 17.8 cm).

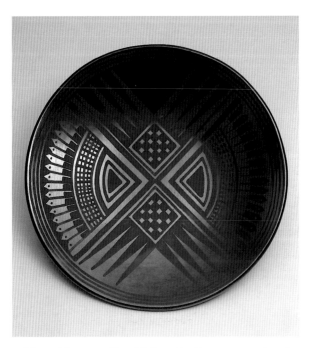

MARIA MARTINEZ (San Ildefonso Pueblo, 1887–1980) and
JULIAN MARTINEZ (San Ildefonso Pueblo, 1885–1943).
Black-on-black pottery plate, c. 1930. New Mexico.
Diameter: 11¾ in. (29.2 cm).

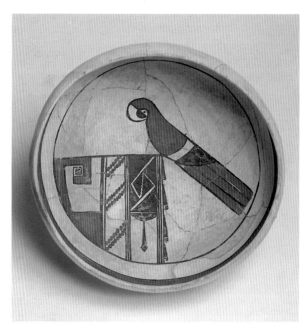

Kechipawan Polychrome bowl, 1375–1475. Hawikku,
New Mexico. Pottery. Diameter: 12 in. (30.5 cm).

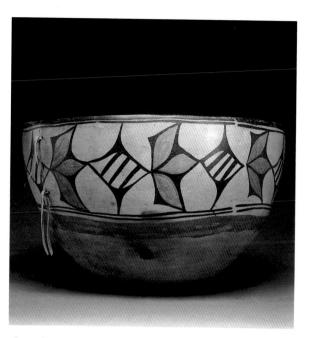

Santo Domingo Pueblo dough bowl, c. 1910. New Mexico.
Polychrome pottery repaired with deerhide thongs.
11⅛ x 19¼ in. (28.3 x 49 cm).

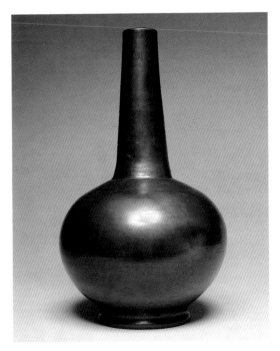

Zapotec vase, n.d. San Bartolo Coyotepec, Oaxaca, Mexico.
Blackware. 7½ x 14¼ in. (19 x 36 cm).

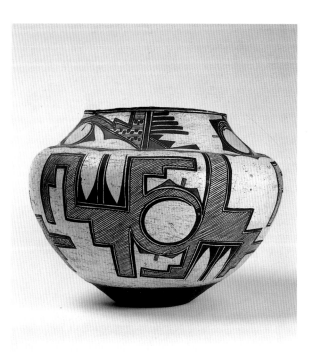

Zuni water jar, c. 1875. Zuni Pueblo, New Mexico.
Polychrome pottery. 11 x 15 in. (28 x 39.5 cm).

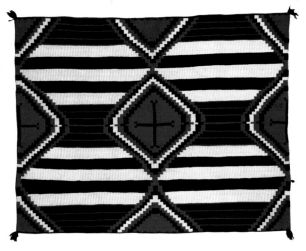

Navajo blanket, n.d. Wool.
61⅞ x 80 in. (152.3 x 202.5 cm).

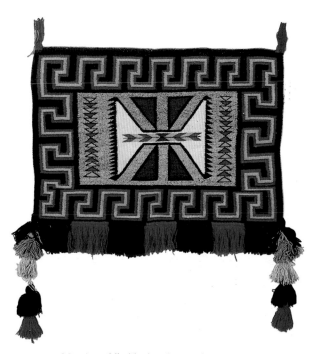

Navajo saddle blanket, late 19th century.
Germantown yarn. 46 x 37½ in. (116.8 x 95.3 cm).

Acoma manta, n.d. Acoma Pueblo, New Mexico. Wool
with embroidered panel. 41½ x 53½ in. (105.5 x 136 cm).

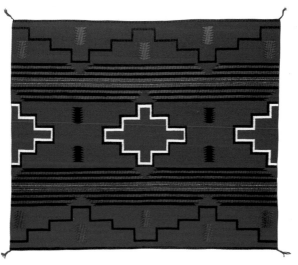

EVELYN CURLY (Navajo, b. 1930). Tapestry, c. 1980. Arizona.
Wool. 57 x 69⅛ in. (145 x 177 cm).

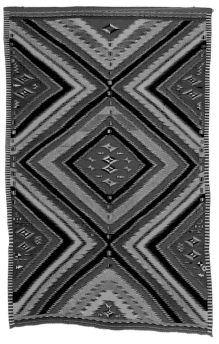

Navajo "Eye Dazzler" textile, n.d. Germantown yarn.
84½ x 56½ in. (214.8 x 143.5 cm).

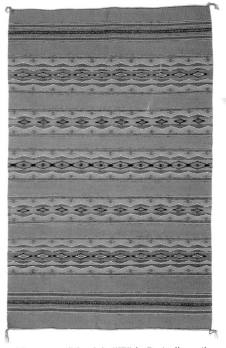

PHYLLIS NOLWOOD (Navajo). "Wide Ruins" textile, 1977.
Arizona. Wool. 70¾ x 46 in. (180 x 117 cm).

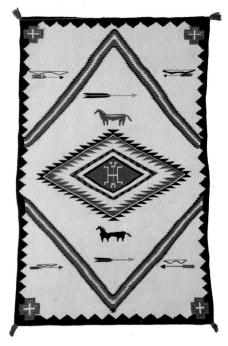

Navajo textile, late 19th century. New Mexico.
Wool. 82 x 54 in. (208.5 x 137.2 cm).

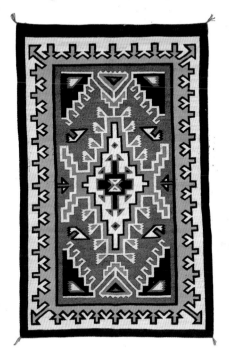

Navajo Two Grey Hills rug, n.d. New Mexico.
Wool. 70¾ x 44½ in. (179.9 x 113.1 cm).

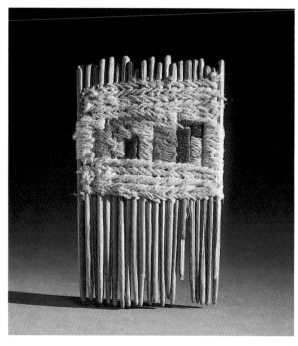

Inka *chhaxrana* (comb), n.d. Peru. Wood with wool.
3 x 1¾ in. (7.6 x 4.5 cm).

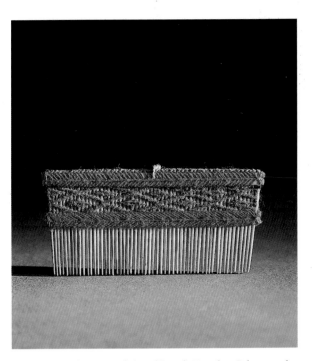

Shuar or Achuar *temash* (comb), n.d. Ecuador. Palm wood woven with cotton threads. 1¼ x 2¾ in. (3.2 x 7 cm).

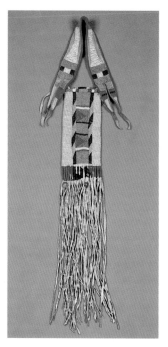

Absaroke (Crow) mirror case, n.d. Montana.
Beaded deerhide. 33⅜ x 5¾ in. (85 x 14.5 cm).

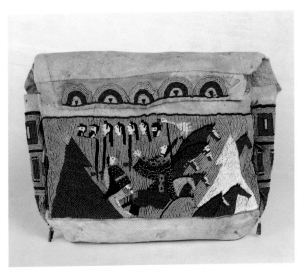

Minneconjou Lakota tipi bag, c. 1885.
Hide with beads, metal, and dyed deer hair.
17¼ x 18½ in. (43.9 x 46.8 cm).

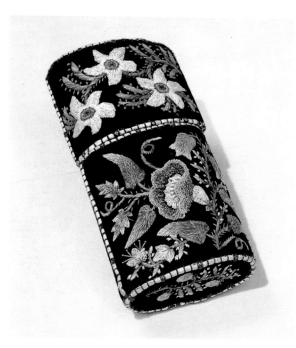

Huron cigar case, early 19th century. Quebec, Canada.
Cloth-covered birchbark with moosehair embroidery.
5¼ x 2¾ in. (13.3 x 7 cm).

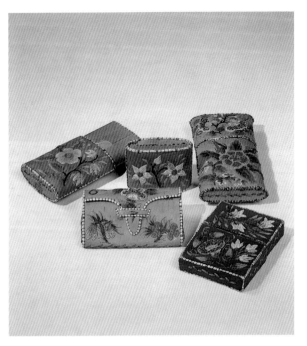

Huron cigar cases, pocketbook, and box, 18th and early
19th century. Quebec, Canada. Birchbark and cloth-covered
birchbark with moosehair embroidery. Heights: 2½ to 4 in.
(6.4 to 10.2 cm); widths: 2⅞ to 4⅛ in. (7.3 to 10.5 cm). 139

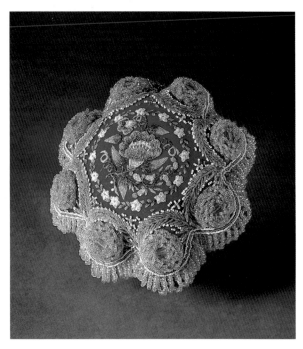

Huron pincushion, 19th century. Canada. Cloth with
moosehair embroidery and glass beads. 2⅞ x 7½ in.
(7.3 x 19 cm).

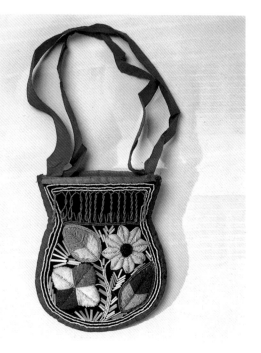

Munsee Delaware pouch, c. 1870. Ontario, Canada. Cloth with beads and ribbon. 6¾ x 5¾ in. (17 x 14.5 cm).

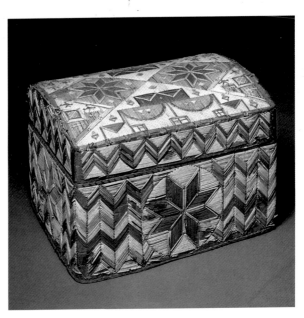

Micmac box, early to mid-19th century. Maine. Birchbark
with quills. 9 x 11 x 7½ in. (23 x 28 x 19 cm).

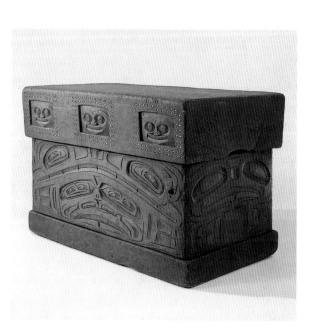

Tsimshian double chest, late 18th–early 19th century.
Klukwan, Alaska. Carved wood. 20½ x 31⅞ in.
(52 x 81 cm).

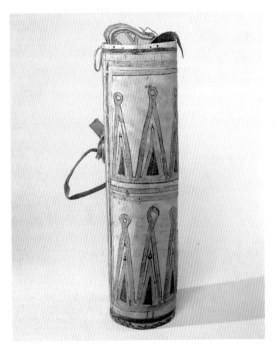

Tsistsistas (Cheyenne) headdress storage case,
late 19th century. Height: 23⅛ in. (57.8 cm).

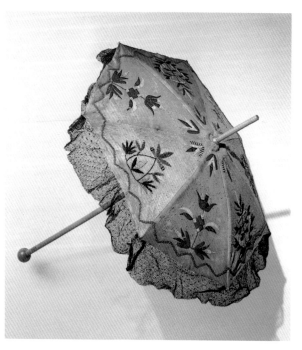

Teton Lakota parasol, n.d. Deerhide with quills and beads.
25¼ x 23 in. (64.5 x 58.5 cm).

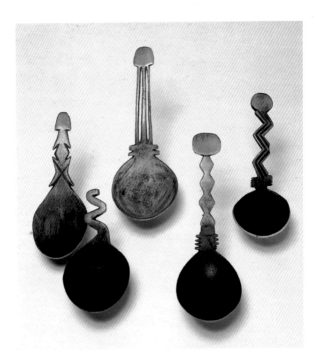

Karuk spoons, late 19th–early 20th century. California.
Carved elk horn. Lengths: 4¾ to 15½ in. (12 to 18.3 cm).

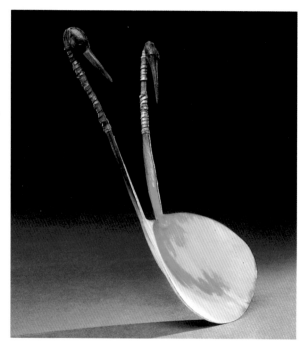

Sioux double-handle spoon, n.d. South Dakota.
Carved horn. 7⅞ x 3⅜ in. (20.1 x 8.6 cm).

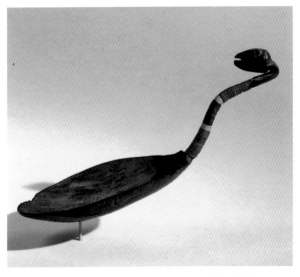

Sioux spoon, n.d. South Dakota. Carved buffalo horn
with quills. 8⅝ x 2¾ in. (21.9 x 7 cm).

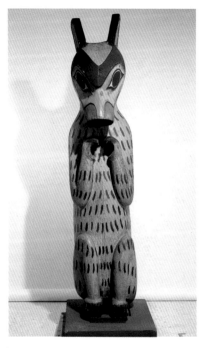

Haida house post, 19th century. Prince of Wales Island,
British Columbia. Carved and painted cedar.
Height: 79 in. (230 cm).

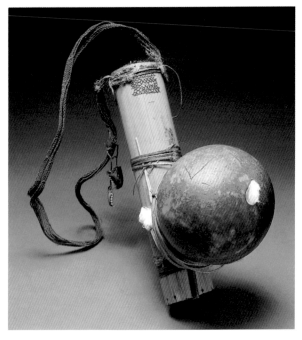

Shuar or Achuar *tunta* (quiver for blowgun darts), n.d.
Ecuador. Bamboo and gourd. 24¾ (with strap) x 5¼ x 7 in.
(63 x 13.5 x 17.8 cm).

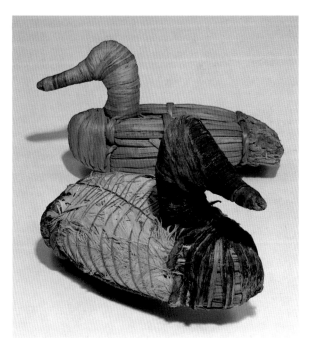

Painted–and–feathered duck decoy and plain duck decoy,
c. 200. Found in Lovelock Cave, Humboldt County, Nevada.
7⅞ x 10½ x 4⅜ in. (20 x 26.5 x 11 cm); 6½ x 10¾ x 3¾ in.
(16.5 x 27 x 9.5 cm).

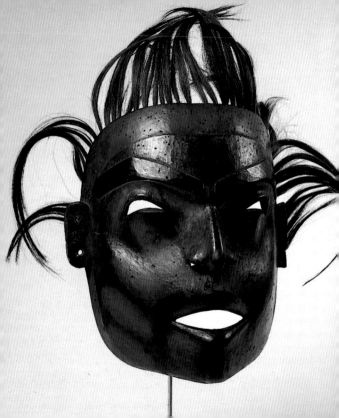

CEREMONIAL AND SACRED OBJECTS

Being Indian traditionally means understanding and living in the natural world. That world is full of living creatures and powerful, unseen spirits. Sometimes it is difficult to separate one from the other. For many Native peoples, spirits are everywhere, in everything—rocks, trees, mountains, rivers. A non-Native may look at the objects illustrated in this chapter and find beauty or insight in them. When Indians see them, something different happens—these works connect us directly to the sources of their power. We understand that power through oral tradition as well as through visual literacy.

Some objects made for ritual use, such as a Nazca spout vessel (page 202), reflect Indian ideas about the creation of the world. Others, like a Taíno *duho* (page 189), document exchanges between individuals, families, or communities and their guardian spirits. Through other objects, like the Karajá *lurina* (page 156), animals share their powers with humankind. Some—drums, rattles, and whistles—were made to be played in sacred ceremonies, while others, like the Inka alpaca effigy

(page 196), were intended to be left as offerings for spirits or deities. Some objects, such as the Cheyenne quilled horse mask (page 187), are not sacred themselves but were made to fulfill vows of faith.

Sacred traditions are not confining sets of rules from the past. Instead, they are principles through which people seek the well-being of the world. Artists work within these traditions so that their creations can be understood by a larger community, yet the traditions allow them to express their own creativity and openness to change. We need only to think of ancient pictures carved in stone—petroglyphs of powerful human, animal, and celestial beings—to understand the depth of Indian spirituality in the Americas and the evolution of its expression through the works of hundreds of generations of Native artists.

The contemporary Native peoples of the Western Hemisphere do not see themselves as relics of the past but as peoples of the present, drawing upon ancient traditions and ways of being to survive in a vastly changed cultural landscape. The sense of connection we feel with our cultural heritage, represented in the museum's collections, is genuine. Out of respect for these living cultures, the museum is careful to avoid publishing objects whose sacredness and power make it inappropriate for them to be seen in printed form. There are, after all,

more than enough things in the museum's collections to fill many chapters on sacred art. For, as this book makes clear, Native artists, through all their works, today as in the past, honor and give thanks to the Creator.

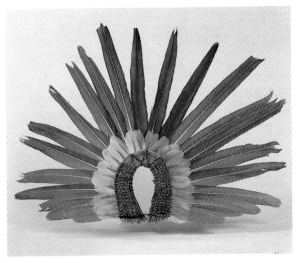

Karajá *lurina* (feather headdress), early 20th century. Brazil.
Scarlet and red-and-green macaw feathers, reeds, palm-leaf
spines, and cotton cord. 23¼ x 30¾ in. (59 x 78 cm).

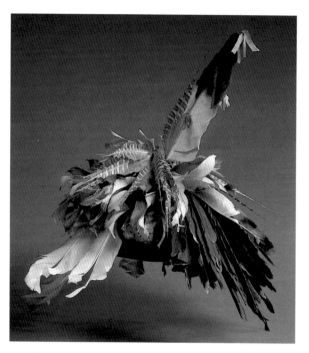

Seneca *gustoweh* (headdress), n.d. Ontario, Canada.
Leather with silver band, wampum beads, and feathers.
20¼ x 24⅜ in. (50.7 x 61 cm).

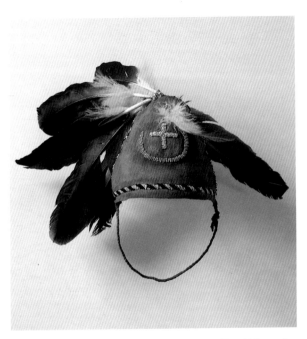

White Mountain Apache hat, n.d. Arizona. Deerhide, eagle
feathers, and glass beads. 9¼ x 18¾ in. (23 x 47 cm).

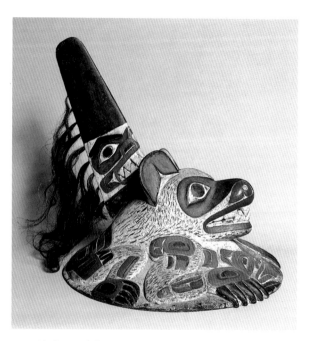

Haida hat with bear and killer whale effigies, n.d. Prince of Wales Island, Alaska. Carved wood. 18¾ x 22 x 19⅝ in. (47.5 x 56 x 50 cm).

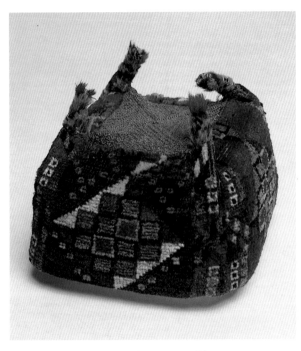

Tiwanaku pile-weave four-cornered hat, 600–1000.
Bolivia. 4⅜ x 5⅛ in. (11 x 13 cm).

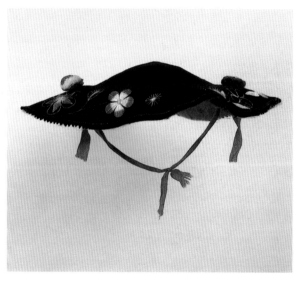

Quechua woman's wedding hat, n.d. Peru. Wool with
embroidered designs and yarn rosettes. 16¾ x 17⅝ in.
(42.5 x 44.75 cm).

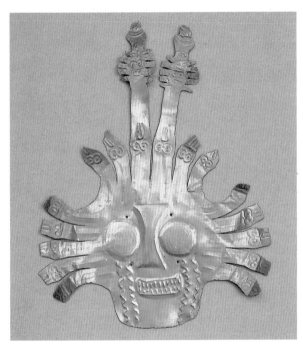

Nazca mask with serpents, 200–600. Peru.
Gold. 9½ x 7½ in. (24 x 19 cm).

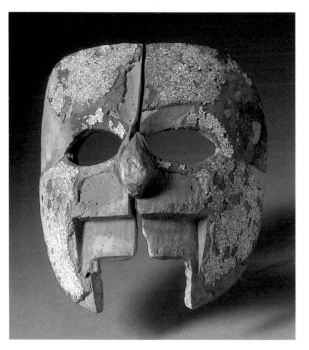

Mixtec mask (in two pieces), n.d. Mexico. Wood inlaid
with turquoise. 7 x 6 x 3⅜ in. (17 x 15.5 x 8.6 cm).

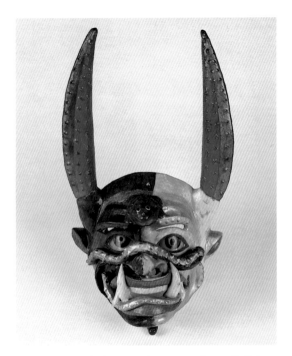

Diablada (devil) dance mask, c. 1924. Oruro, Bolivia.
Gesso and plaster over felt with bottle-glass eyes.
16½ x 9⅛ in. (42 x 23 cm).

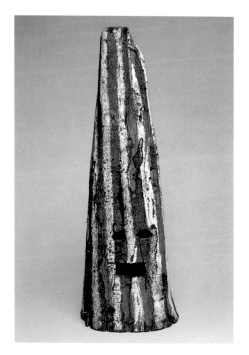

Yamana *hílix* (mask), early 20th century. Argentina. Bark.
26½ x 9 in. (67.5 x 23 cm).

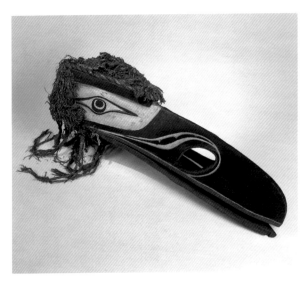

Kwagu'ł (Kwakiutl) mask representing Raven, late 19th–early
20th century. Vancouver Island, British Columbia, Canada.
Carved and painted wood. Width: 35⅝ in. (89 cm).

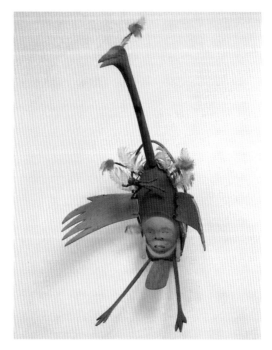

Yup'ik dance mask, late 19th century. Kuskokwim River, Alaska. Carved and painted wood. 39 x 28 x 16 in. (99 x 71 x 40.5 cm).

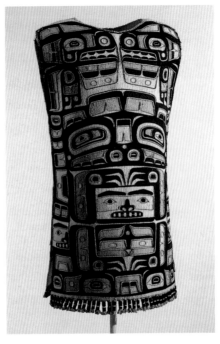

Chilkat Tlingit tunic with Bear design, 19th century. Alaska. Goat wool and cedar bark. Length: 38⅜ in. (96 cm).

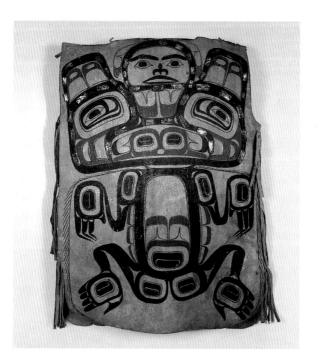

Tsimshian tunic with Bear and mountain spirit designs, early to mid-19th century. British Columbia, Canada. Painted hide. 32½ x 23 in. (78 x 60 cm).

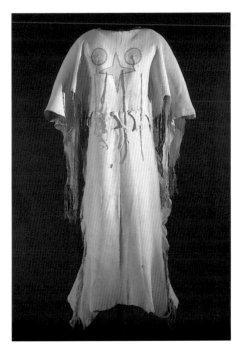

Kiowa Ghost Dance dress, n.d. Oklahoma.
Painted deerhide. Length: 59 in. (147.5 cm).

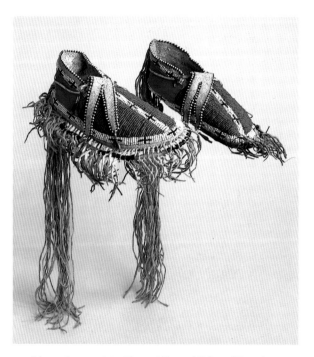

Moccasins, c. 1860. Upper Missouri River, Wyoming.
Beaded hide. 30⅞ x 4⅞ in. (78.5 x 12.5 cm).

Eastern Woodlands wampum belt, 18th century(?).
Length: 39⅛ in. (97.8 cm).

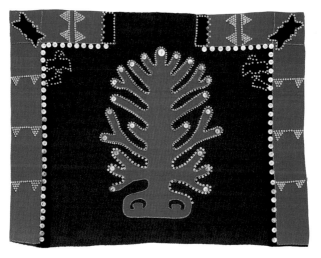

Kwagu'ł (Kwakiutl) button blanket, late 19th–early 20th century. British Columbia, Canada. Wool broadcloth, red wool flannel, and mother-of-pearl buttons. 55 x 71½ in. (139.7 x 182 cm).

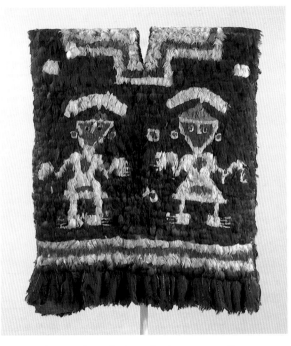

Chimú culture feather tabard, 900–1450. Peru.
29⅞ x 25¾ in. (76 x 65 cm).

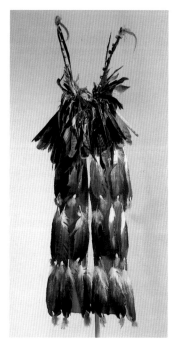

Ponca man's dance bustle, n.d. Oklahoma. Feathers, bells, and cloth. 54¼ x 18¼ in. (135.7 x 45.7 cm).

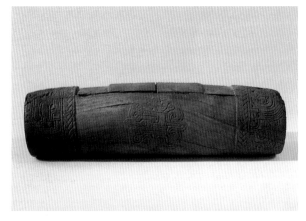

Aztec *teponaztli* (wooden drum) with 1493 glyph.
Tlaxcala, Mexico. 17¼ x 4⅝ in. (43.8 x 11.6 cm).

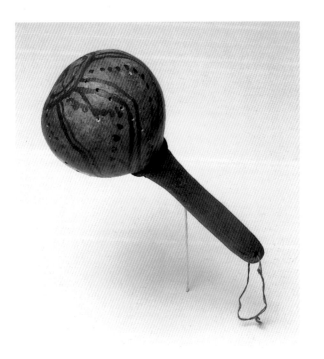

Chemehuevi rattle, n.d. Southwestern United States.
Painted gourd with wooden handle. 11 x 14⅞ in.
(28 x 37.6 cm).

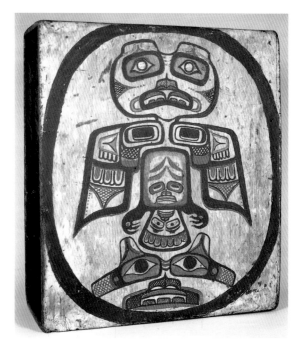

Tlingit box drum with owl-crest design, late 19th century.
Alaska. Painted wood with inlaid haliotis shells.
37 x 32¾ x 13½ in. (93.5 x 83.5 x 34.5 cm).

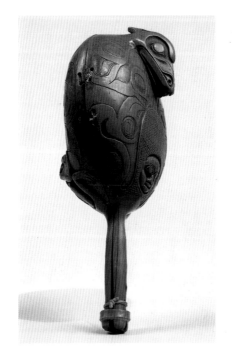

Gitksan rattle representing a frog and a beaver,
late 19th–early 20th century. British Columbia, Canada.
Carved wood. Height: 14 in. (35 cm).

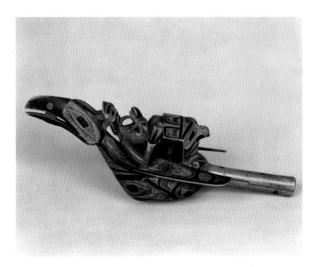

Haida dance rattle, 1850–75. Skidegate, Queen Charlotte Island, British Columbia, Canada. Carved cedar fiber. Length: 13 in. (32.5 cm).

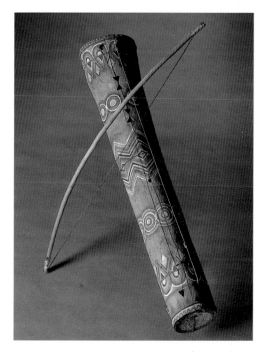

White Mountain Apache *nadah benagolze* (violin and bow),
n.d. Arizona. Agave, pigment, baling wire, and horsehair
strings. 26⅞ x 6⅝ in. (67.3 x 16.6 cm).

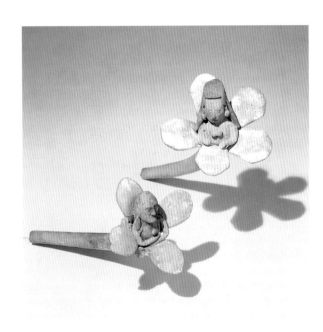

Maya whistles, 550–850. Jaina Island, Mexico. Pottery.
Lengths: 5⅜ in. (13.5 cm); 4¾ in. (11.8 cm).

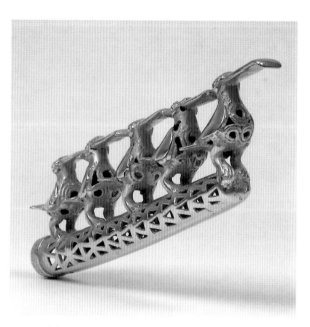

Sinú culture staff head, 1000–1600. Colombia. Gold.
2¼ x 8 in. (5.7 x 20.3 cm).

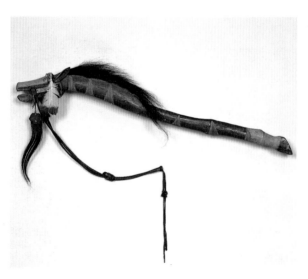

Teton Lakota (?) dance stick, n.d. North Dakota. Carved and painted wood. 35 x 13¾ x 3⅛ in. (89 x 35 x 8 cm).

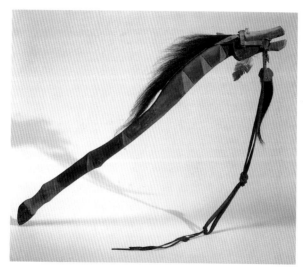

Teton Lakota dance stick, n.d. Northern Plains. Carved and painted wood. 35 x 3½ in. (89 x 8 cm).

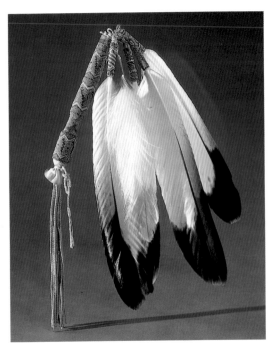

Kiowa peyote fan, n.d. Oklahoma. Beaded deerhide, twisted
cording, and eagle feathers. 29¾ x 11 in. (75.5 x 28 cm).

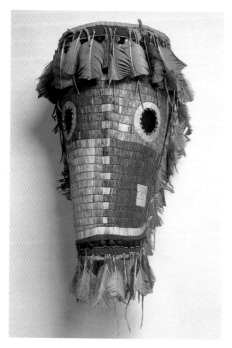

Tsistsistas (Northern Cheyenne) quilled horse mask,
late 19th century. 22⅜ x 29 in. (55.8 x 72.3 cm).

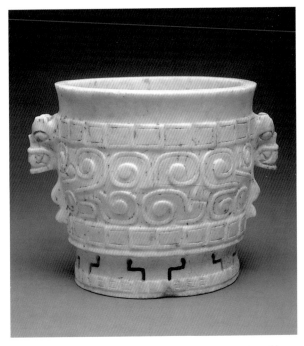

Vessel, 800–1000. Ulúa Valley, Honduras. Carved marble.
5¼ x 7 in. (13.3 x 17.8 cm).

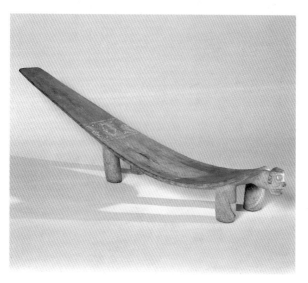

Taíno *duho* (wooden seat), 1200–1492. Turks and
Caicos Islands. Carved and painted wood.
34½ x 6⅛ in. (88 x 15.5 cm).

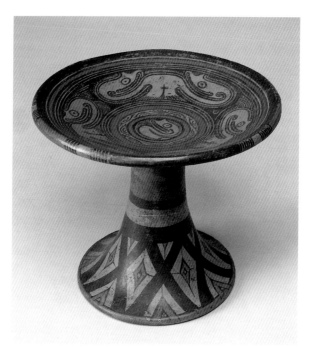

Cocle pedestal dish, 600–800. Collected from the province of Veraguas, Panama. 8½ x 9⅞ in. (21.5 x 25 cm).

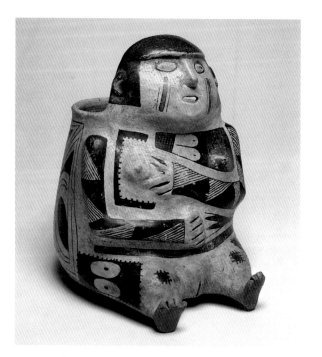

Effigy jar, 1150–1450. Casas Grandes, Mexico.
Pottery. 9⅞ x 8⅞ in. (25.1 x 22.5 cm).

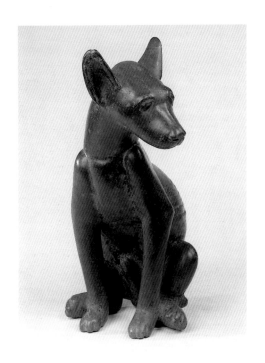

Effigy vessel, 400 B.C.–A.D. 300. Colima, Mexico.
13¼ x 7½ in. (33.6 x 19.5 cm).

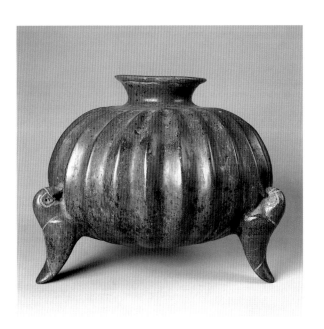

Gadrooned vessel with parrot tripod supports, 400 B.C.–
A.D. 300. Colima, Mexico. Height: 8⅝ in. (21.6 cm).

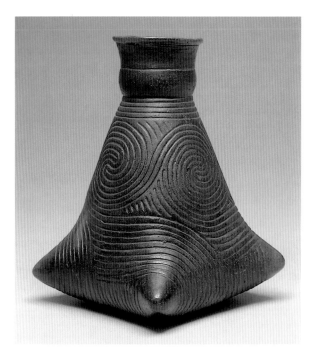

Late Mississippian (Caddoan) jar, 1300–1700.
Ouachita Parish, Louisiana. Height: 5⅝ in. (14 cm).

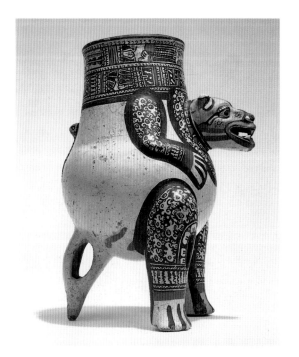

Jaguar effigy vessel, 1200–1550. Found in
Guanacaste-Nicoya, province of Puntarenas, Costa Rica.
Height: 15½ in. (38.7 cm).

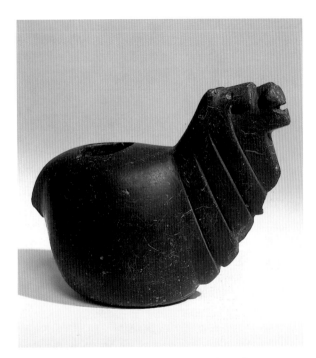

Inka alpaca effigy, 1470–1532. Peru. Carved stone.
Height: 3¾ in. (9.5 cm).

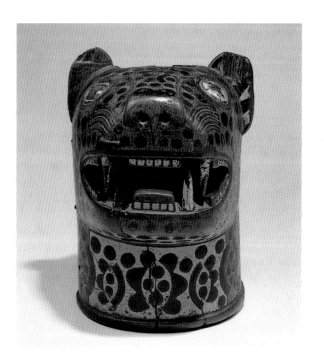

Inka jaguar *q'iru* (cup), mid-16th century. Peru. Carved and painted wood. 8¾ x 7¼ x 8⅞ in. (22.2 x 18.4 x 22.5 cm).

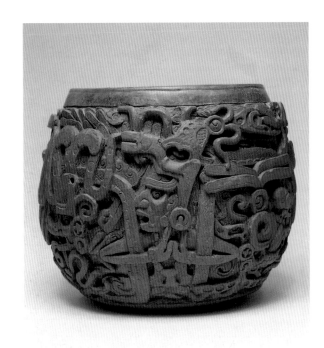

Maya bowl, 400–550. Guatemala. Sculpted and carved
pottery. 8 x 8½ in. (20.2 x 21.6 cm).

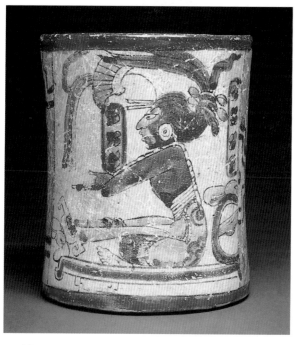

Maya vase, 550–850. Campeche, Mexico. Polychrome
pottery. 6½ x 5⅛ in. (16.4 x 14.2 cm).

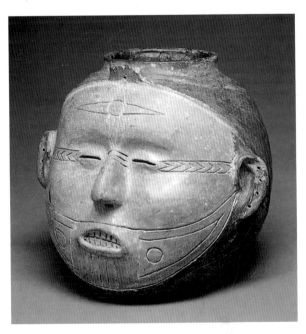

Middle Mississippian (Nodena phase) vessel, 1300–1500.
Pottery. 6¼ x 7⅜ in. (15.6 x 18.5 cm).

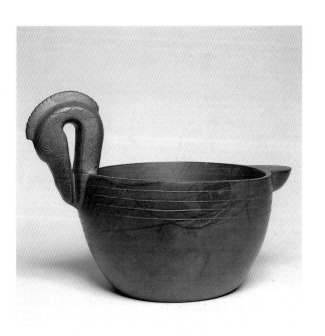

Middle Mississippian wood-duck effigy bowl, 1250–1500.
Alabama. Carved diorite. 11⅜ x 15¾ in. (29 x 40 cm).

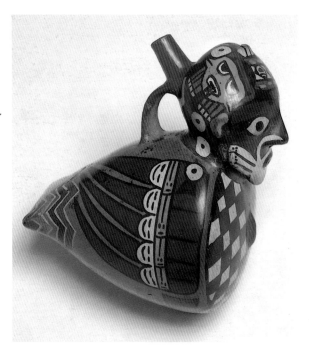

Nazca spout vessel, 200–600. Peru.
7¼ x 6⅜ in. (18.4 x 16.2 cm).

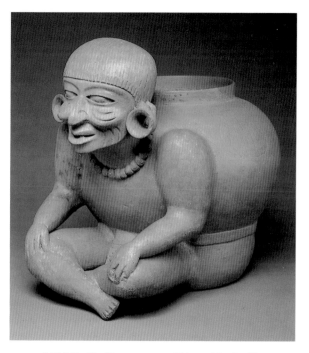

"Old God" effigy, 200–750. Toluca, Mexico(?).
12 x 9½ x 13¾ in. (30.6 x 24.2 x 34.8 cm).

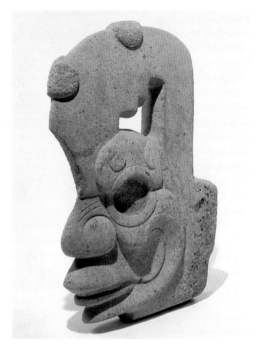

Hacha (ceremonial ax), 600–900. Veracruz, Mexico.
Carved stone. Height: 12 in. (30 cm).

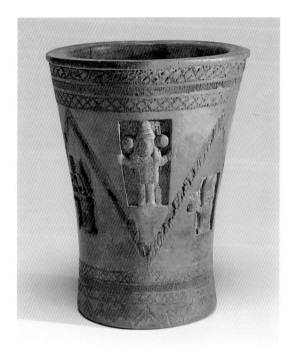

Tiwanaku or Inka *q'iru* (cup), n.d. Peru. Painted and incised wood. 6 x 5¾ in. (15.2 x 14.6 cm).

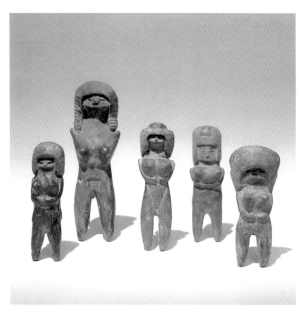

Figurines, c. 3200 B.C. Valdivia, Ecuador. Pottery.
Heights: 3⅜ to 5 in. (8.5 to 12.7 cm).

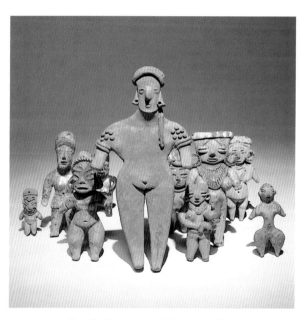

Female figurines, n.d. Mexico. Clay.

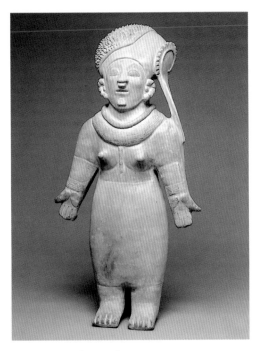

Jama–Coaque figure of a woman, 250 B.C.–A.D. 250.
Central coast of Manabi, Ecuador. Pottery.
Height: 18⅜ in. (47.5 cm).

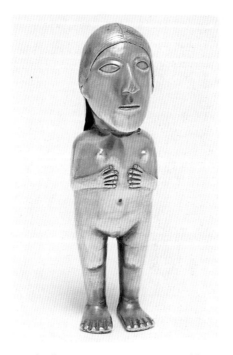

Inka figurine, 1470–1532. Peru. Gold.
9⅞ x 3 in. (25 x 7.5 cm).

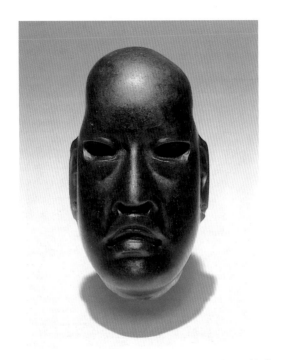

Olmec head, 900–400 B.C. Palenque, Mexico. Carved jade.
2¾ x 1⅝ in. (7 x 4.1 cm).

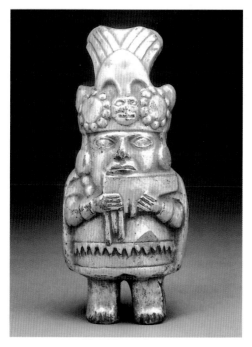

Moche panpipe player figure, 100–600. Peru. Silver.
Height: 6¾ in. (17 cm).

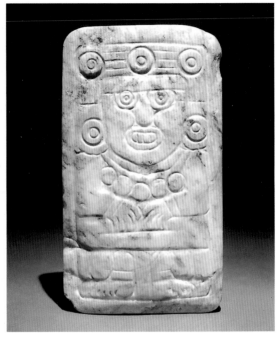

Mixtec–Zapotec plaque, n.d. Mexico. Carved jade.
6¾ x 3⅜ in. (15.2 x 8.5 cm).

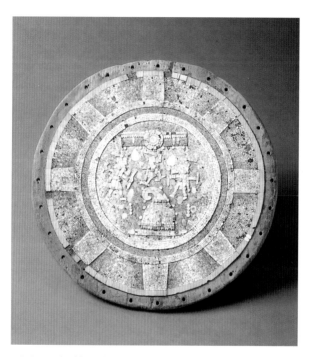

Mixtec shield, 15th century. Puebla, Mexico. Wood inlaid with turquoise. Diameter: 13 in. (33 cm).

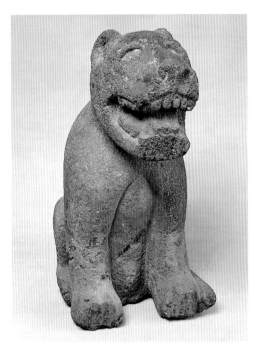

Aztec snarling jaguar figure, 1400–1500.
Mexico. Carved scoria.

Seal, 1000–1500.
Guerrero, Mexico. Pottery.

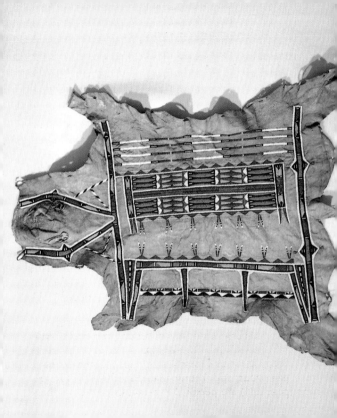

EXPRESSIONS OF
PERSONAL VISION

Ideas for artistic expression came to Indians in many different ways. Close community and family interaction between elders and the young provided for the handing down of values, beliefs, and means of expression from one generation to the next. In each Native community, certain symbols and motifs were recognized as expressions of community values, but these works were not created simply by replicating patterns of the past. Even within a community, seldom were any two works the same. Within the framework of family, community, and cultural identity, the individual creativity of the artist was expressed.

Scholars have often defined Native art as "traditional" if it closely followed the standards of the past and conformed to certain aesthetic principles. In reality, Indian art has been in a constant state of evolution, changing with each generation as new designs, combinations of elements, and personal visions of beauty have been introduced. In this chapter the design, style, and colors in such objects as Crazy Horse's shirt (page 2), Spotted Tail's shirt (page 224), and Young Man Afraid of His Horse's robe (page 237) are personal expressions of their makers

and wearers while also representing styles and designs distinctive to the communities that produced them. Drawings, paintings, and weavings depicting events such as a Yeibechai ceremonial dance (pages 240, 241), a warrior's exploits (page 247), or a personal vision (page 250) reinforce the artist's personal and cultural identity. Using familiar or new materials, ideas, and designs, Indian artists seek ways to make their work meaningful to themselves and to their community.

For some Native artists, retaining a unique tribal style is important, and many still preserve ancestral patterns of belief. For these artists, there is great personal satisfaction in reaffirming their tribal identity through the arts. The persistence of imagery in Pueblo pottery is one such example. There are great differences, however, in the pottery made by contemporary Pueblo artists and that made by their ancestors a thousand years ago. The designs and patterns are adapted from older forms, but the techniques have changed. Today's work looks somewhat mechanical—thin, even walls and exactness of painting—to satisfy the tastes of the consumer. Yet Pueblo pottery is considered very traditional if it is made entirely by hand, from native clays, and fired in the old way. Both old and new styles are "authentically" Pueblo and reflect cultural values as well as personal expression.

Other Native artists derive satisfaction from reconfiguring patterns of the past into new statements of iden-

tity and belief. The mastery of beadwork is an example of this approach. Most people consider beadwork a traditional Indian art form, but glass beads were first introduced through trade with Europeans. Since then, each tribal group has used the same materials—glass beads, spun thread, steel needles—to produce a style of beadwork unique to its own community. A Crow sword scabbard (page 228), for example, displays beaded geometric forms outlined in white, a common element in Crow beadwork. Beads were sometimes used to create designs that had previously been made with other materials, such as quills or paint. A Sioux deerskin is beaded in a "box and border" style, a design often seen on Sioux painted robes (page 216). Over time, there has been much crossover and sharing of styles and techniques among Native artists.

Each piece represented here required great individual creativity and skill to produce. The artists drew upon older sources, experimented with new ideas, and executed those ideas with patience and skill. These works were made on purpose, made by hand, and made to be used to express each individual's system of belief.

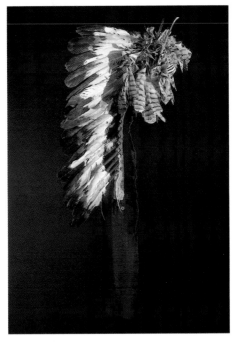

Absaroke (Crow) headdress, n.d. Montana.
Owl and eagle feathers, wool trade cloth, and buffalo hide.
56¾ x 13¼ in. (142 x 33 cm).

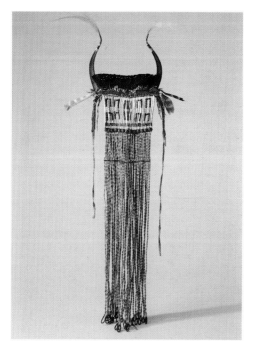

Assiniboine headdress, mid-19th century. Antelope horns tipped with horsehair, feathers, leather strapping, deerhide fringe, and quills. 33¼ x 7¼ in. (84.5 x 18.5 cm).

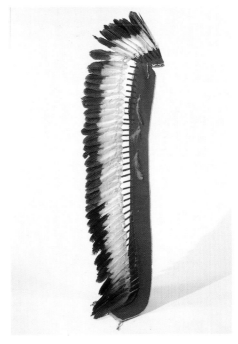

Tsistsistas (Cheyenne) headdress, c. 1870. Oklahoma.
Golden-eagle tail feathers on trade-cloth cap and trailer.
Length: 79⅜ in. (198.5 cm).

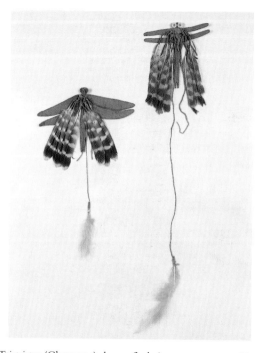

Tsistsistas (Cheyenne) dragonfly hair ornaments, c. 1885.
Montana. Rawhide with feathers. 13 x 9⅞ in. (33 x 25 cm);
24¾ x 5⅜ in. (63 x 13.5 cm).

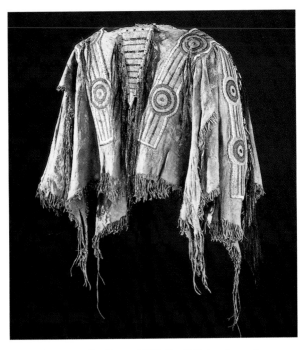

Shirt worn by Spotted Tail (Brulé Lakota), c. 1855.
Painted hide with hair, quills, and beads.
32 x 63 in. (81.5 x 160 cm).

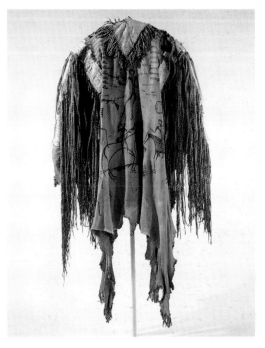

Shirt, mid–19th century. Upper Missouri River(?).
Painted hide, quills, and beads. Length: 61⅛ in. (154 cm).

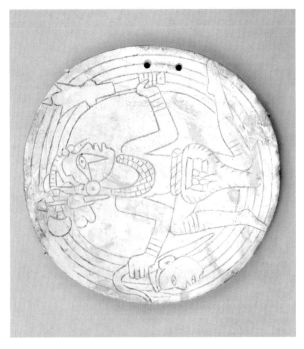

Middle Mississippian gorget with human
figure design, 1250–1300. Tennessee. Conch shell.
4 x 3¾ in. (10 x 9.5 cm).

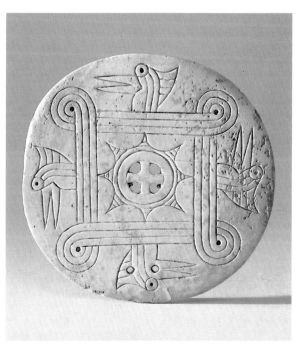

Middle Mississippian gorget with woodpecker
design, 1250–1300. Tennessee. Conch shell.
Diameter: 3⅛ in. (8 cm).

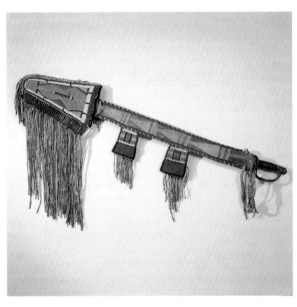

Absaroke (Crow) sword scabbard, late 19th century.
Montana. Hide and hide cord edged with flannel.
52¾ x 25¼ in. (134 x 64 cm).

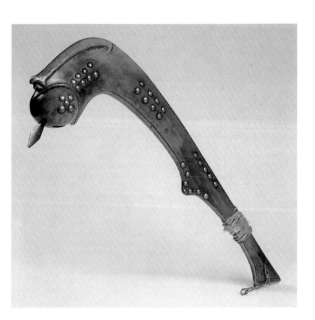

Oto effigy war club, 19th century. Oklahoma.
Wood. Length: 23¾ in. (59.7 cm).

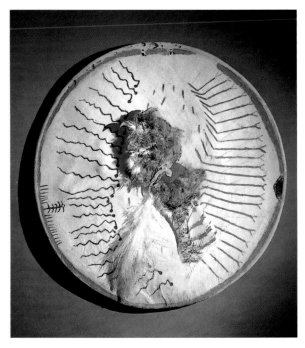

Absaroke (Crow) shield, n.d. Montana. Painted buffalo hide with owl ornament. Diameter: 21⅝ in. (54 cm).

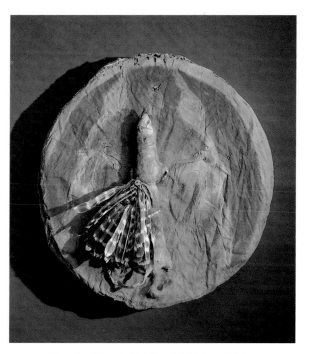

Absaroke (Crow) shield, n.d. Northern Plains.
Painted deerhide with weasel skin and feathers.
Diameter: 21⅝ in. (54 cm).

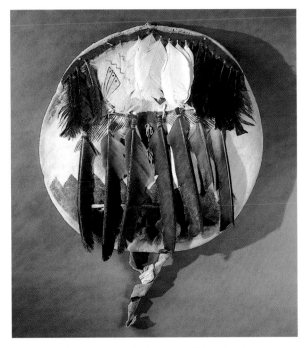

Absaroke (Crow) thunderbird shield, n.d.
Northern Plains. Painted buffalo hide with feathers.
Diameter: 22⅝ in. (56.5 cm).

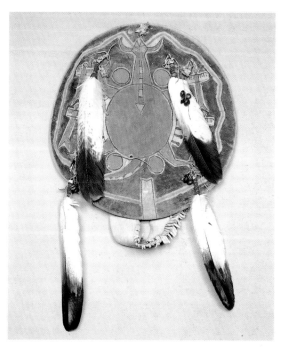

Northern Plains shield with turtle image, n.d.
Diameter: 19⅝ in. (50 cm).

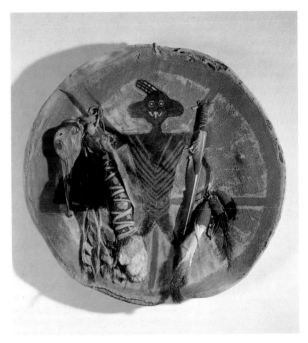

ARAPOOSH (SORE BELLY) (Absaroke [Crow], d. 1834). Shield,
c. 1830. Montana. Deerhide with flannel cloth, pigment,
stork, deer tail, and feathers. Diameter: 24¼ in. (61.5 cm).

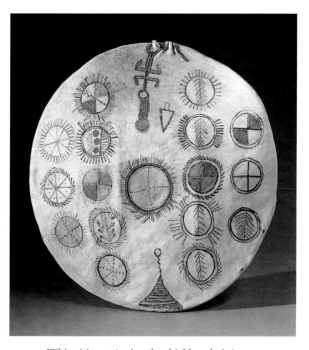

White Mountain Apache shield, n.d. Arizona.
Painted deerhide. Diameter: 18½ in. (47.6 cm).

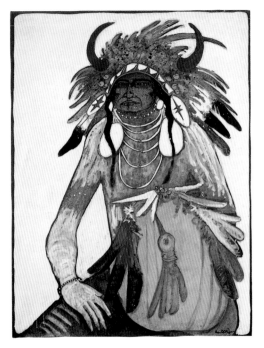

KEVIN RED STAR (Absaroke [Crow], b. 1942).
Bird's Head Shield, 1981. New Mexico. Acrylic and mixed
media on canvas. 42¾ x 31⅞ in. (107 x 81 cm).

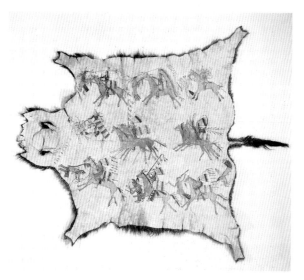

Buffalo robe, worn by Young Man Afraid of His Horse
(Oglala Lakota), c. 1880. South Dakota. Painted buffalo hide.
69 x 88 in. (175.5 x 223.5 cm).

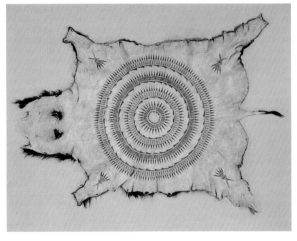

Numakiki (Mandan) painted robe, c. 1875. Fort Berthold
Reservation, North Dakota. Hide. 71 x 100¼ in.
(180.5 x 254.7 cm).

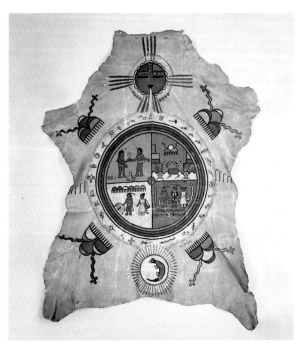

FRED KABOTIE (Hopi, 1900–1986).
Legend of the Snake Clan, n.d. Oraibi, Arizona. Watercolor
and graphite on paper. 22⅝ x 18⅞ in. (57.5 x 48 cm).

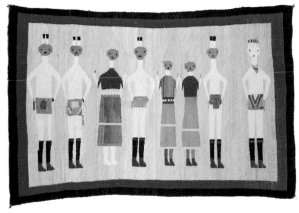

Navajo Yeibechai textile, n.d. Wool.
47 x 70⅝ in. (119.5 x 179.6 cm).

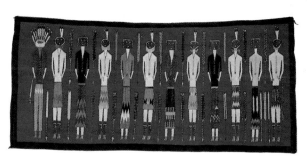

Navajo Yeibechai textile, 20th century. Arizona.
Wool. 42¼ x 91½ in. (107.3 x 232.5 cm).

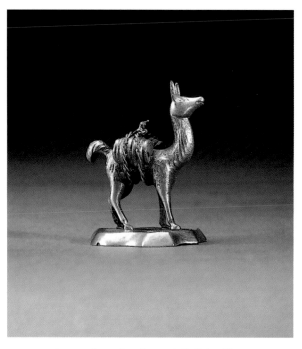

Aymara llama figurine, n.d. Bolivia. Silver.
1⅞ x 1½ x 1⅛ in. (5.3 x 3.7 x 3.2 cm).

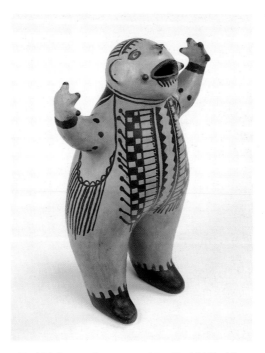

Cochiti figure of a man, c. 1880. Cochiti Pueblo,
New Mexico. Pottery. 18⅜ x 12¼ in. (46.7 x 31.1 cm).

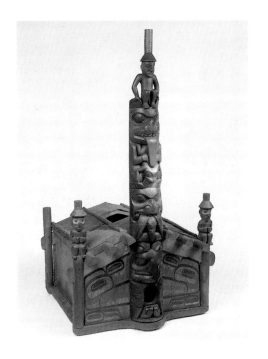

Haida house model, late 19th century.
British Columbia, Canada. Carved and painted wood.
35⅜ x 18⅞ x 16½ in. (90 x 48 x 42 cm).

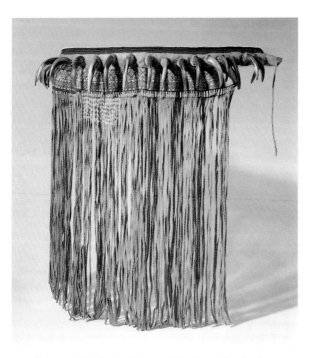

Slavey quilled belt, 1860–70. Northwest Territories,
Canada. 36 x 24¼ in. (91.5 x 61.5 cm).

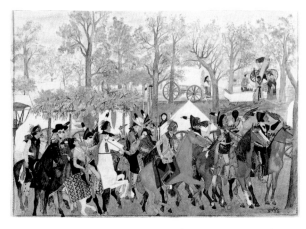

EARNEST L. SPYBUCK (Absentee Shawnee, 1883–1949).
Procession before War Dance, c. 1910. Oklahoma. Watercolor
on paperboard. 17⅜ x 25⅛ in. (44.2 x 63.9 cm).

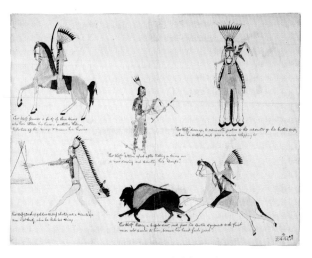

Artist Unknown (probably Hidatsa).
The Exploits of Poor Wolf, Hidatsa Second Chief,
early 20th century(?). Crayon, watercolor, and ink
on paper. 18⅜ x 22⅜ in. (43 x 56 cm).

247

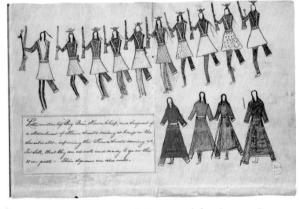

CHIEF BIG BOW (Kiowa). Letter and drawing, c. 1875.
8 x 12¼ in. (20.5 x 31 cm).

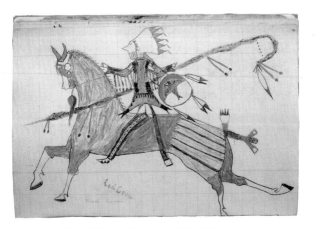

RED DOG (Lakota). Drawing of Red Crow in page
from book of drawings, late 19th century. South Dakota.
Crayon and ink on paper. 5⅛ x 7⅝ in. (12.7 x 19.1 cm).

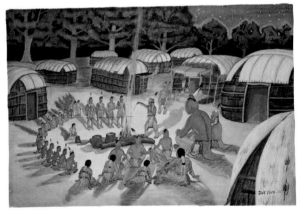

W. Richard West, Sr. (Wah-pah-nah-yah)
(Tsistsistas [Southern Cheyenne], b. 1912).
Dark Dance of the Little People, 1948. Oklahoma. Opaque
watercolor on paper. 12 x 18 in. (30.5 x 45.8 cm).

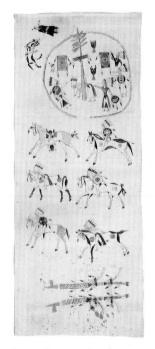

BLACK CHICKEN (Yanktonai).
Graphic interpretation of the Sun Dance, late 19th century.
Painted muslin. 86 x 36 in. (190.6 x 91.5 cm).

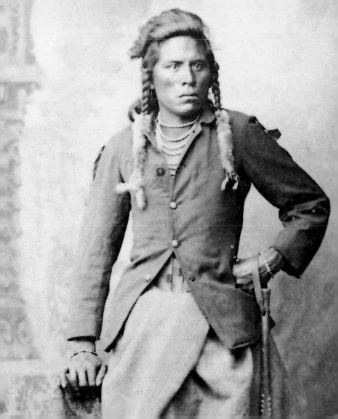

PHOTOGRAPHY

With some 86,000 images—including 47,000 negatives, 30,000 vintage prints, and 9,000 transparencies—the Photographic Archives of the National Museum of the American Indian constitute one of the world's foremost collections depicting Native American culture and history. Ranging from historic daguerreotypes to contemporary Cibachrome prints, the photographs reflect the history of the medium as well as the ideas and intent of the photographers who created them.

Historical photographs of Native Americans show a people caught in a clash of cultures and politics. They illustrate not only the devastating effects of these conflicts on Native cultures but also the strength and resilience demonstrated in the face of such devastation. The social, cultural, and political context of each photograph plays a crucial role in the finished product. Many of these photographs used staged settings, props, and poses to produce images that would reinforce cultural stereotypes for political or other purposes; sometimes these photographs reveal little more than cultural assumptions or the photographer's preconceived ideas about "Indianness."

In the studio, photographers often dressed Indian subjects in European-style clothing, posing them in the rigid, formal style of the period. Such images emphasized the notion of the Indian as Noble Savage, caught between two worlds (page 252). Other photographers chose to show Indian subjects in full traditional dress; many posed for photographers in their finest clothing and jewelry. In the field, photographers sometimes used their own fake backdrops, props, and costumes, creating images in which one Indian might be used to represent all of his or her people, or even all Native Americans (page 261). Photographs depicting the effects of colonization on Native life reinforced the idea of the Vanishing American, doomed to be swept away by the advancing tide of "civilization" (pages 270, 279). Photographs of Indian delegations to Washington in the late nineteenth and early twentieth century often depict Native peoples dressed in both traditional and European-style clothing, posed in front of buildings or artworks—images intended to illustrate the greatness of America and the inevitability of Manifest Destiny (page 289).

The value of photographic collections depicting Native Americans is evident in the words of Linda Poolaw (Delaware–Kiowa)—a researcher, playwright, and educator, and the daughter of noted photographer Horace Poolaw. She describes taking students from a class in photo documentation at Stanford University back to her

home in Oklahoma to do research on her father's photographs. "I was concerned about bringing these young people home with me—most of them had had very little contact with Indians and I wasn't sure if this would work. But I was really more frightened of the Indian people than of anything else. I was afraid they would say, 'Get out of here, we don't want to talk to you.' But at some point, after turning on the tape recorders and looking at two thousand photographs, the people were just wonderful. The Kiowas really wanted to talk because they were seeing images in those photographs that some of them could just remember and that their grandchildren had never seen. They were dragging their grandchildren in, saying, 'Look at my grandma, look at my grandpa.' I know it brought back memories."

Today, contemporary Indian photographers point the camera at themselves, using photography to interpret their own stories. The museum continues to collect photographs of Native life and culture. Of special interest are photographs documenting contemporary Indian experience and works by Native photographers, whose images raise challenging questions regarding the personal and cultural use of the medium.

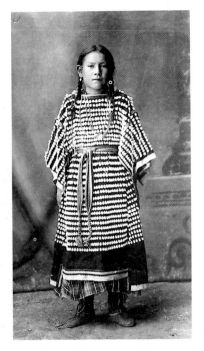

Brulé Lakota girl in cowrie-shell dress, n.d.
North Dakota.

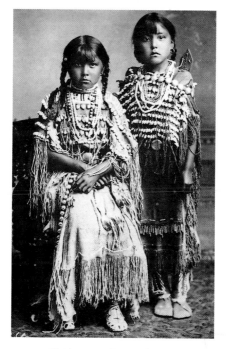

Hunkpapa Lakota girls, n.d.

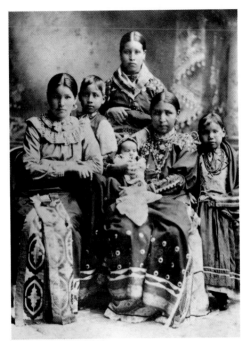

Studio portrait of Prairie Potawatomis Lizzie Mitchell (left)
and Am-Kwan (seated, center), with her children, n.d.
Mayetta, Kansas.

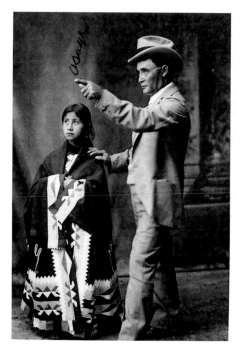

Man with Osage girl in ribbonwork blanket, c. 1900.
Paul Warner Collection.

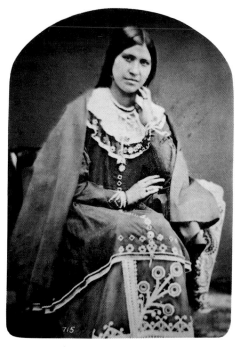

Ge-Keah-Saw-Sa (Caroline Parker), a member of the
Wolf Clan and relative of General Ely S. Parker (Seneca),
c. 1870. New York.

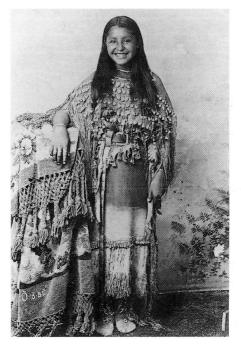

O-o-be (Kiowa), 1895. Fort Sill, Oklahoma.

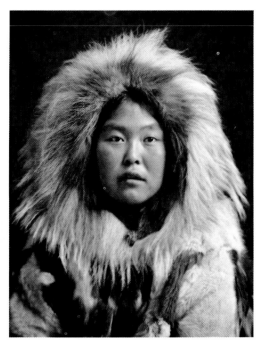

Native woman, 1907. Nome, Alaska.
Photograph by F. H. Nowell.

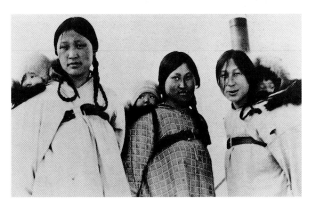

Eskimo women and their children, n.d.

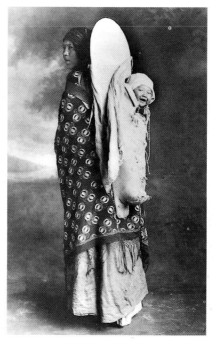

Blackfeet mother and child, n.d. Glacier National Park,
Montana. David C. Vernon Collection.

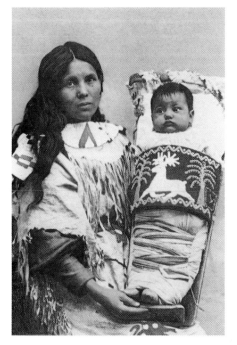

Mary Beauvais with her daughter Ori-Wi-Io-Ston
(Pious, or Margaret Beauvais), Mohawk, n.d.
Caughnawaga, Quebec, Canada.

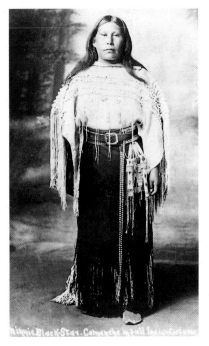

Minnie Black Star (Comanche), n.d. Oklahoma.

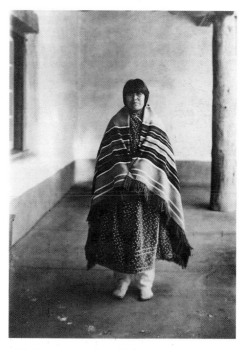

Maria Martinez, San Ildefonso Pueblo potter,
standing under the porch of the Palace of the
Governors, Santa Fe, New Mexico, 1925.

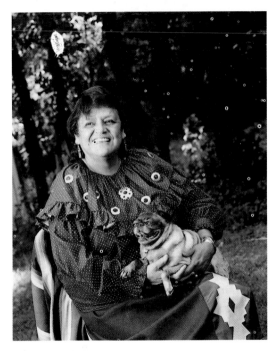

Linda Poolaw (Delaware–Kiowa), 1994.
Photograph by David Neel.

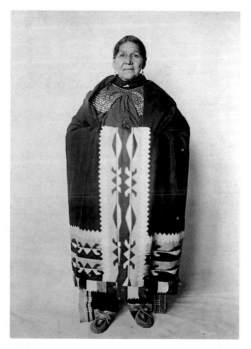

Delaware woman, n.d. Near Bartlesville, Oklahoma.
Photograph by M. R. Harrington.

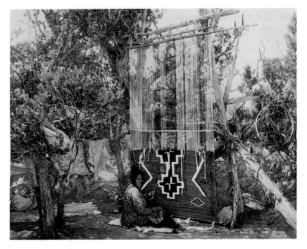

Navajo woman weaving, c. 1892.

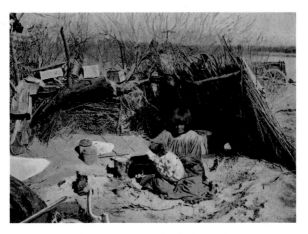

Pima woman weaving basket, n.d.

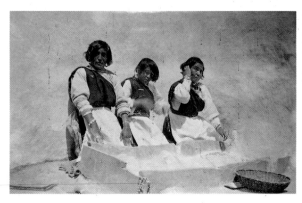

Zuni women grinding corn, c. 1922. Zuni Pueblo,
New Mexico. Photograph by D. A. Cadzow.

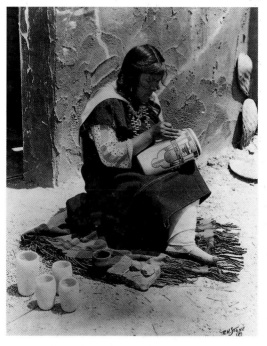

Nampeyo, Hopi–Tewa potter, n.d.
New Mexico.

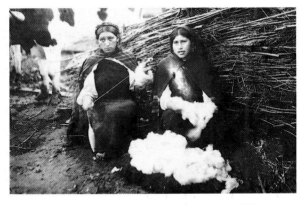

Mapuche women spinning, n.d. Temuco, Chile.

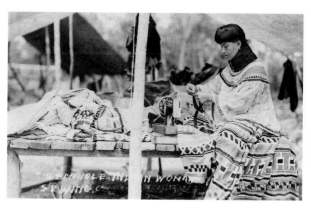

Seminole woman sewing, n.d. Florida.

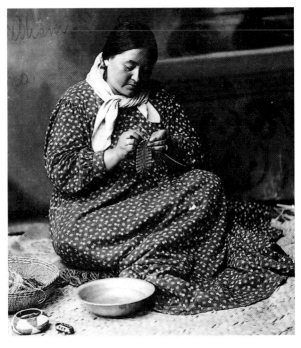

Mary Benson, Pomo basketmaker, 1904.
Louisiana Purchase Centennial Exposition, Saint Louis.

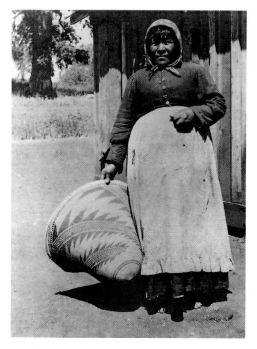

Pomo woman with basket, n.d. California.
Photograph by Grace Nicholson.

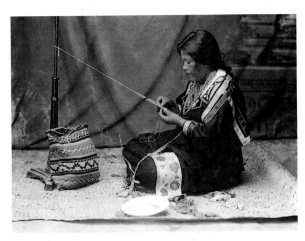

Me-Gay-Zeuce (Eagle, or Jane Walters) (Ojibwe),
doing beadwork, n.d. Minnesota.

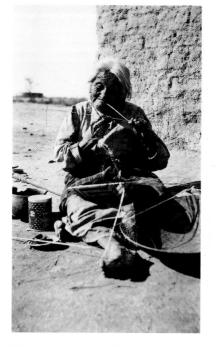

Pima woman splitting basket fiber, 1921.
Blackwater, Arizona. Photograph by Edward H. Davis.

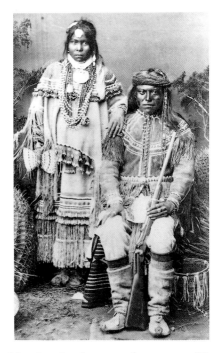

Mescalero Apache man and woman, c. 1884.
Photograph by Randall.

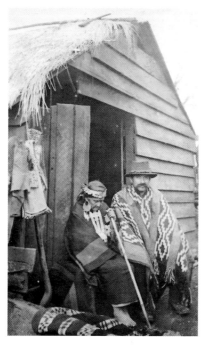

Mapuche couple, n.d. Temuco, Chile.

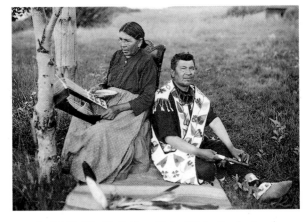

Juni-Mii-We-Gi-Ji-Gons (John White Feather) and
his wife, Na-Wa-Que Gi-Ji Go-Kwe (Chippewa), n.d.
Lac du Flambeau, Wisconsin.

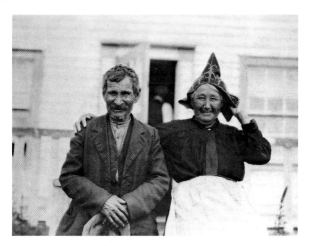

Mr. and Mrs. Andrew Joe (Micmac), 1931.
Conne River Reserve, Newfoundland, Canada.
Photograph by Frederick Johnson.

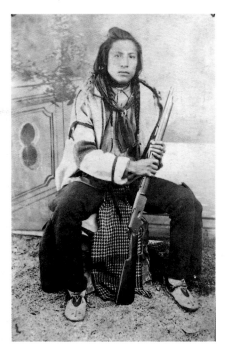

Running Wolf (Piegan), n.d.

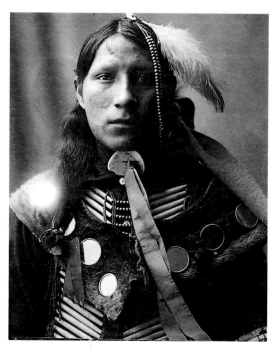

Sleeping Bear (Oglala Lakota), c. 1900.
North Dakota.

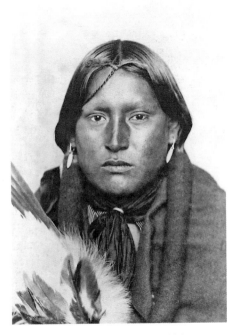

Kiowa man, 1895. Fort Sill, Oklahoma.

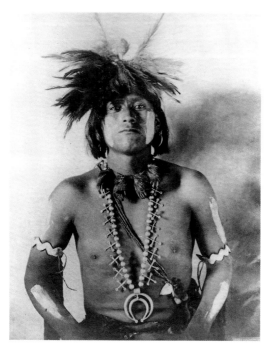

Taqui, a Hopi Snake Priest, n.d. Arizona.

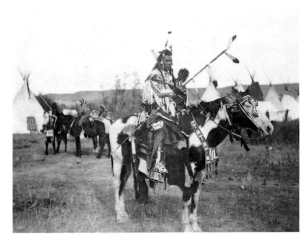

Spotted Rabbit (Absaroke [Crow]), n.d. Montana.
Photograph by William Wildschut.

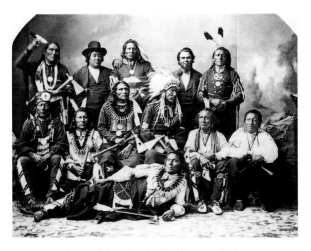

Ponca delegation in Washington, D.C.,
November 14, 1877.

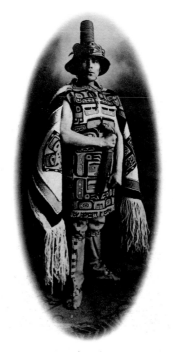

Louis Shotridge (Tlingit), 1914.
Photograph by William Witt.

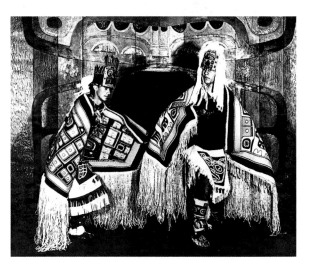

Chilkat dancers, n.d. Haines, Alaska.

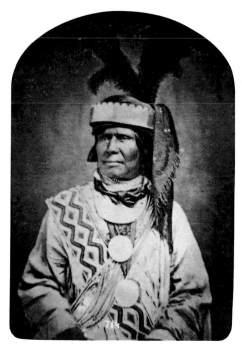

Billy Bowlegs, Seminole chief, 1869. Florida.
Photograph by W. H. Jackson.

Antoine Moise (Flathead), 1898. Omaha.
Photograph by Rinehart.

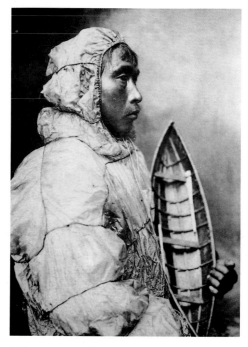

Eskimo man with model *umiak* (open boat), n.d.
Point Barrow, Alaska.

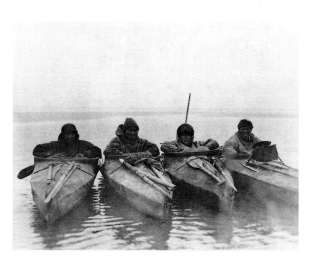

Eskimo seal hunters, 1926. Mouth of the Kuskokwim
River, Alaska. Photograph by Clark M. Barber.

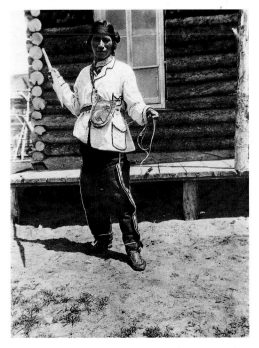

Innu hunter, Michikamau band, 1924. Seven Isles, Quebec,
Canada. Photograph by Frank G. Speck.

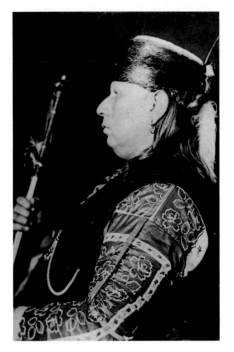

Chief Bacon Rind (Osage), 1908.

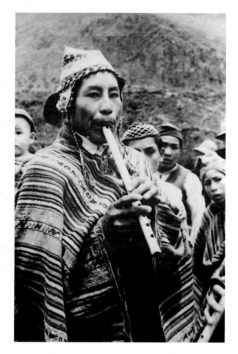

Quechua flute player, n.d. Peru.
Gift of Miss Beate Salz.

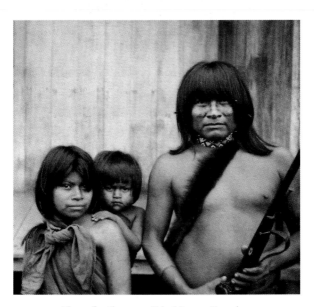

Shuar family, 1935. Río Upano, Ecuador.

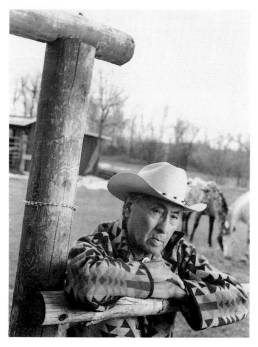

Joseph Medicine Crow (Absaroke [Crow]), 1994.
Photograph by David Neel.

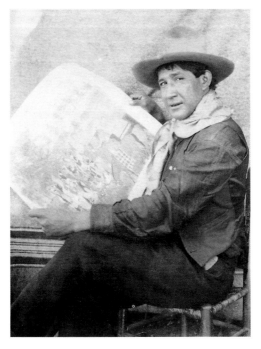

Earnest L. Spybuck, Shawnee painter, 1910. Oklahoma.
Photograph by M. R. Harrington.

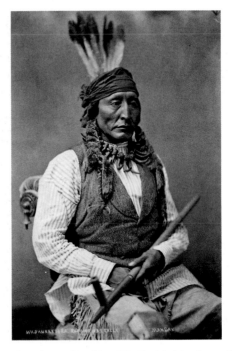

Washunakoora (Rushing War Eagle), Mandan, n.d.

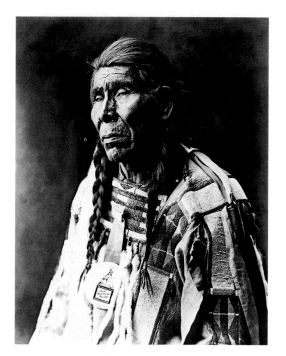

Blackfoot man. Montana.

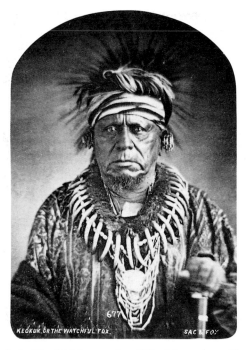

Keokuk (Watchful Fox, or One Who Moves about Alert),
a Sac and Fox war chief, 1847. Daguerreotype by
Thomas M. Easterly, Saint Louis.

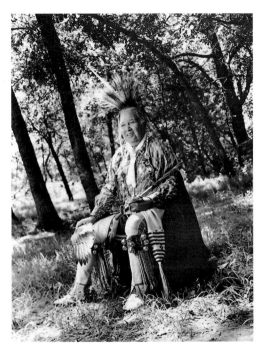

Abe Conklin (Ponca–Osage), 1994.
Photograph by David Neel.

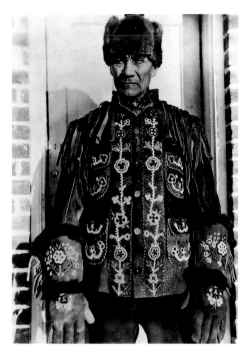

Cree man, n.d. Northwest Territories, Canada.

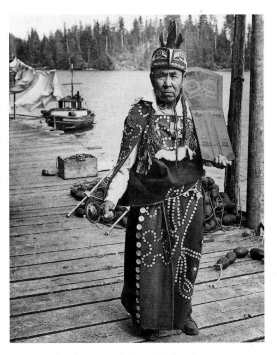

Kwághitola, Kwagu'ł (Kwakiutl) artist, c. 1960.
British Columbia, Canada.

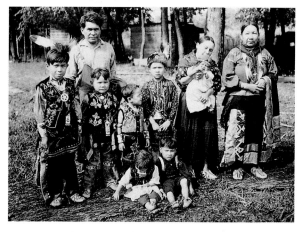

White Breast's family (Mesquakie), n.d.
Tama, Iowa.

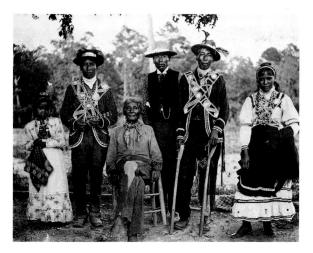

Choctaw group, 1909. Mississippi.
Photograph by M. R. Harrington.

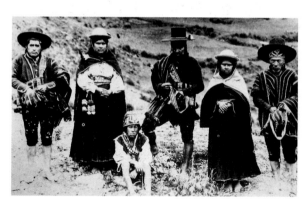

Aymara group, 1929. Bolivia.

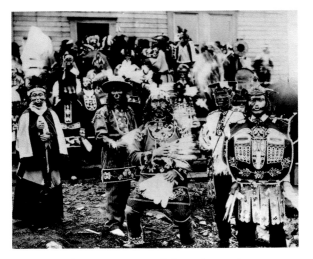

Tlingit group in ritual dance dress, n.d.
Chilkat, Alaska.

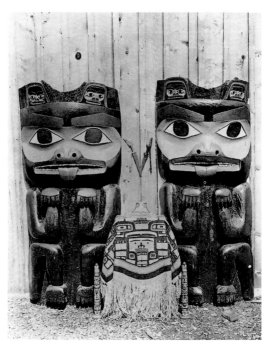

Haida Bear Clan house posts and Chilkat robe,
1882. Masset, British Columbia, Canada.
Photograph by R. Maynard.

INDEX

PHOTOGRAPHY CREDITS

The objects in this book were photographed by David Heald, except the following (numerals refer to pages): 32, 136–37, 164, 178, 180, 249, Pamela Dewey (NMAI); 127, 130–32, 241, Katherine Fogden (NMAI); 26, 159, 233, Karen Furth (NMAI); 124, 214, Carmelo Guadagno (NMAI); 184, 239, photographer unidentified. Historical images are from the NMAI Photo Archives; 268, 300, 305, copyright © David Neel.

Head of Publications, NMAI: Terence Winch
Editor, NMAI: Cheryl Wilson
Editor, Abbeville: Nancy Grubb
Designer: Sandy Burne
Production Editor: Owen Dugan
Production Manager: Lou Bilka

First edition
10 9 8 7 6 5 4 3 2 1

Library of Congress Cataloging-in-Publication Data
Treasures of the National Museum of the American Indian / foreword by
 W. Richard West, Jr. ; introduction by Charlotte Heth ; texts by Clara Sue
 Kidwell and Richard W. Hill, Sr.
 p. cm.
 "A tiny folio."
 Includes index.
 ISBN 0-7892-0105-4
 1. Indians of North America—Art—Catalogs. 2. Indians of North America
 —Material culture—Catalogs. 3. Indians—Art—Catalogs. 4. Indians—
 Material culture—Catalogs. 5. National Museum of the American Indian
 (U.S.)—Catalogs. I. West, W. Richard, Jr. II. Kidwell, Clara Sue. III. Hill,
 Richard W., Sr. IV. National Museum of the American Indian (U.S.)
 E98.A7T72 1996
 700'.89'97—dc20 95-38529

SELECTED TINY FOLIOS™ FROM ABBEVILLE PRESS

- **American Impressionism** 1-55859-801-4 ▪ $11.95
- **Angels** 0-7892-0025-2 ▪ $11.95
- **The Art of Tarot** 0-7892-0016-3 ▪ $11.95
- **Audubon's Birds of America:**
 The Audubon Society Baby Elephant Folio 1-55859-225-3 ▪ $11.95
- **The Great Book of French Impressionism** 1-55859-336-5 ▪ $11.95
- **The North American Indian Portfolios:**
 Bodmer, Catlin, McKenney & Hall 1-55859-601-1 ▪ $11.95
- **Treasures of Folk Art:**
 The Museum of American Folk Art 1-55859-560-0 ▪ $11.95
- **Treasures of Impressionism and Post-Impressionism:**
 National Gallery of Art 1-55859-561-9 ▪ $11.95
- **Treasures of the Louvre** 1-55859-477-9 ▪ $11.95
 French-language edition: 2-87878-153-8
- **Treasures of the Musée d'Orsay** 1-55859-783-2 ▪ $11.95
 French-language edition: 1-55859-043-3
 Japanese-language edition: 4-89023-203-6
- **Treasures of the Musée Picasso** 1-55859-836-7 ▪ $11.95
 French-language edition: 1-55859-044-1
 Japanese-language edition: 1-55859-884-7
- **Treasures of 19th- and 20th-Century Painting:**
 The Art Institute of Chicago 1-55859-603-8 ▪ $11.95
- **Treasures of the Uffizi** 1-55859-559-7 ▪ $11.95
- **Wild Flowers of America** 1-55859-564-3 ▪ $11.95